Hungry Horse / Pieter ten Hoopen

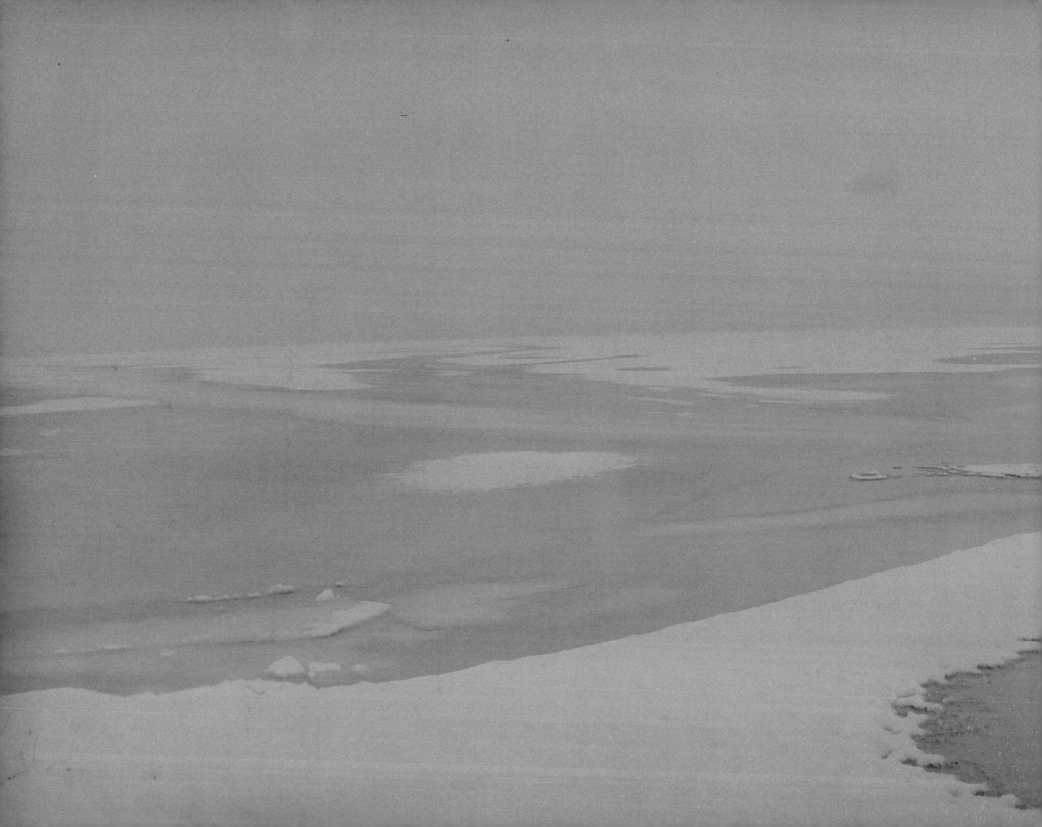

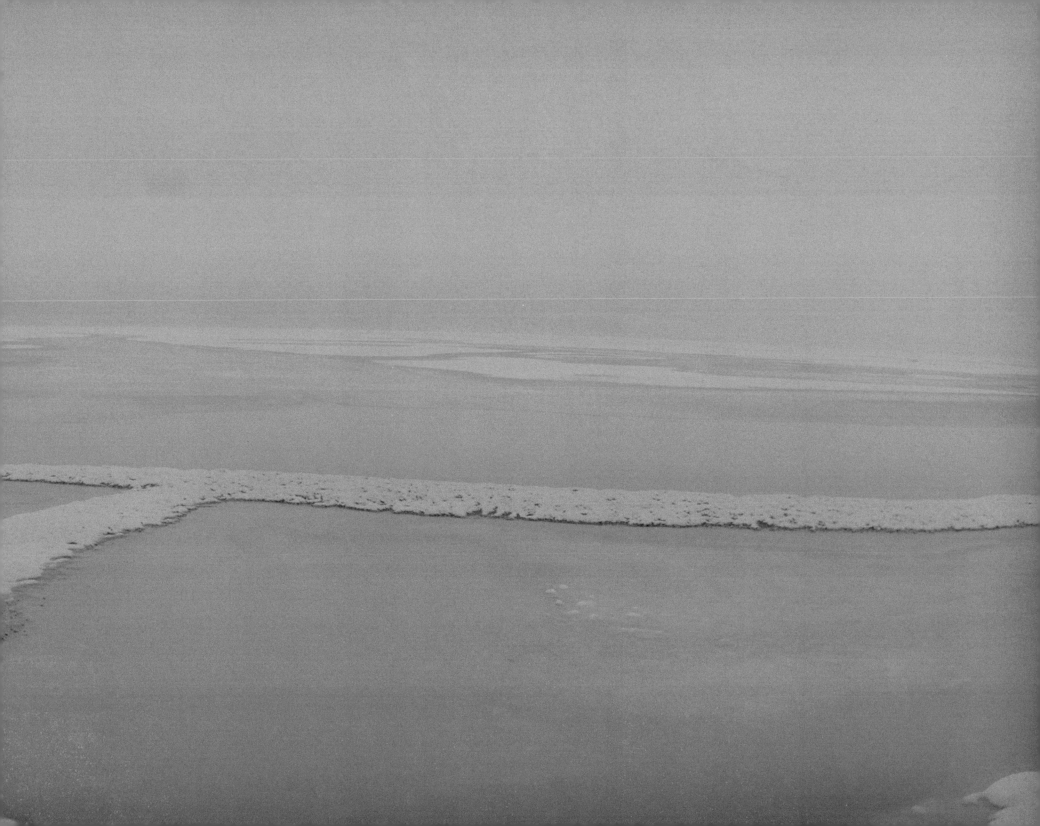

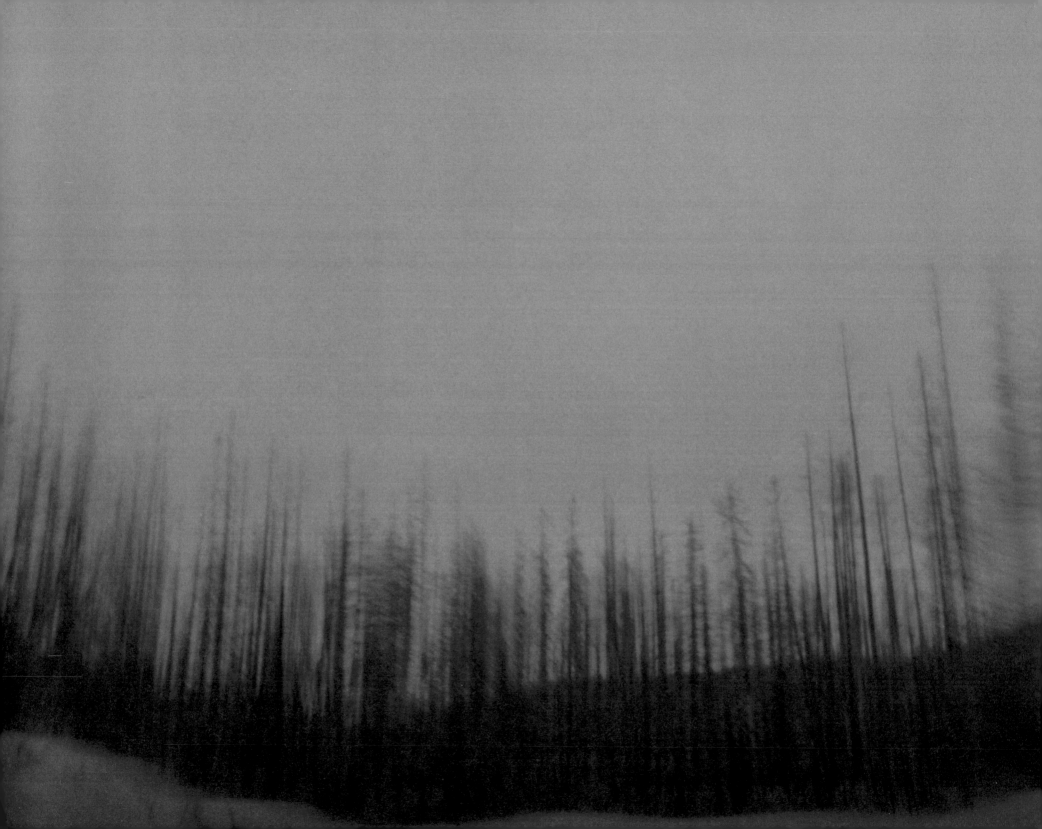

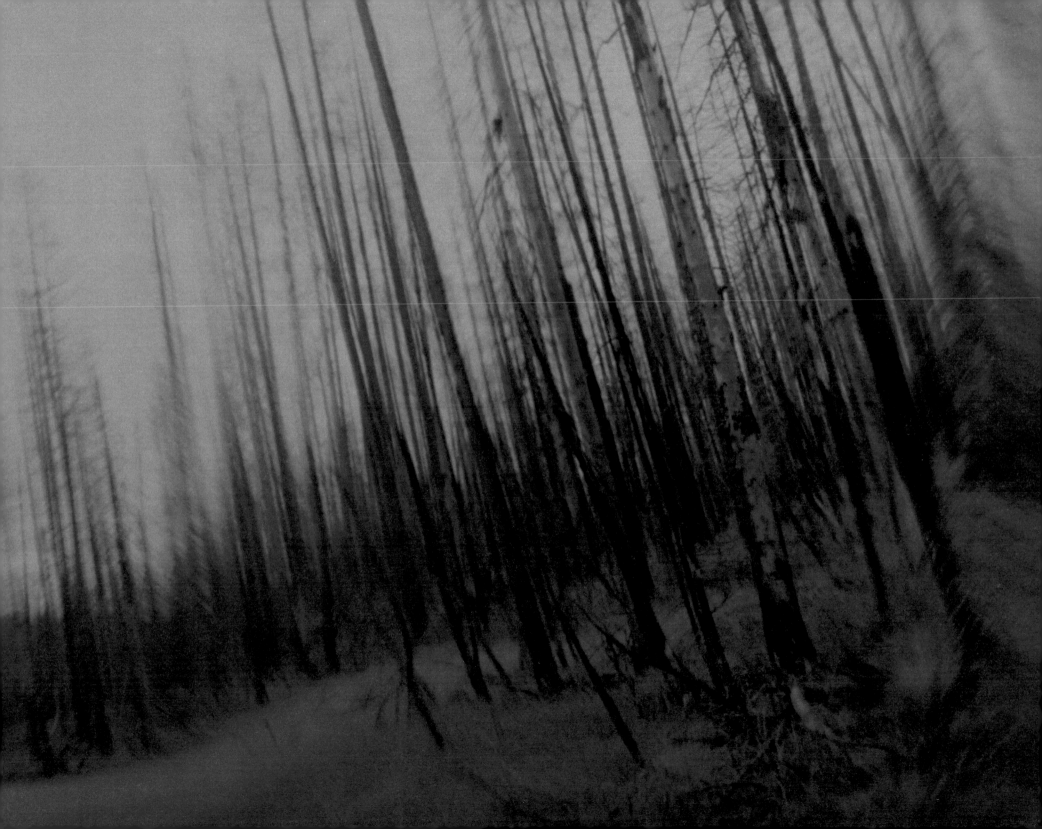

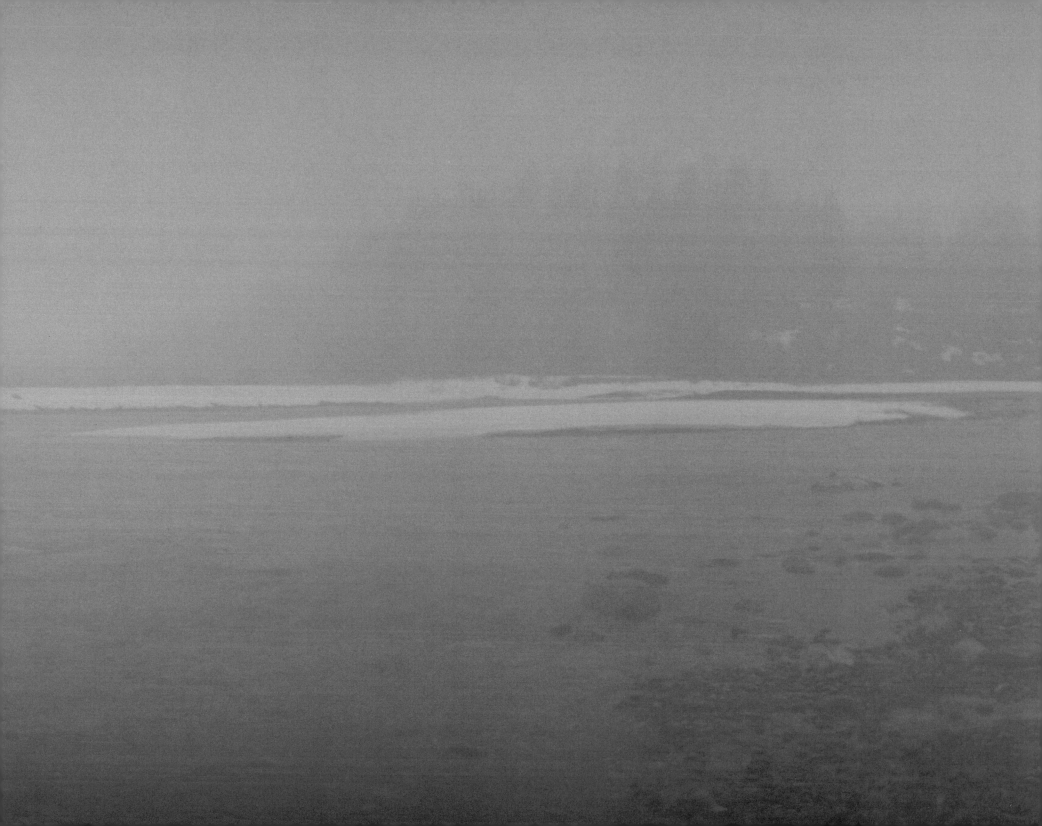

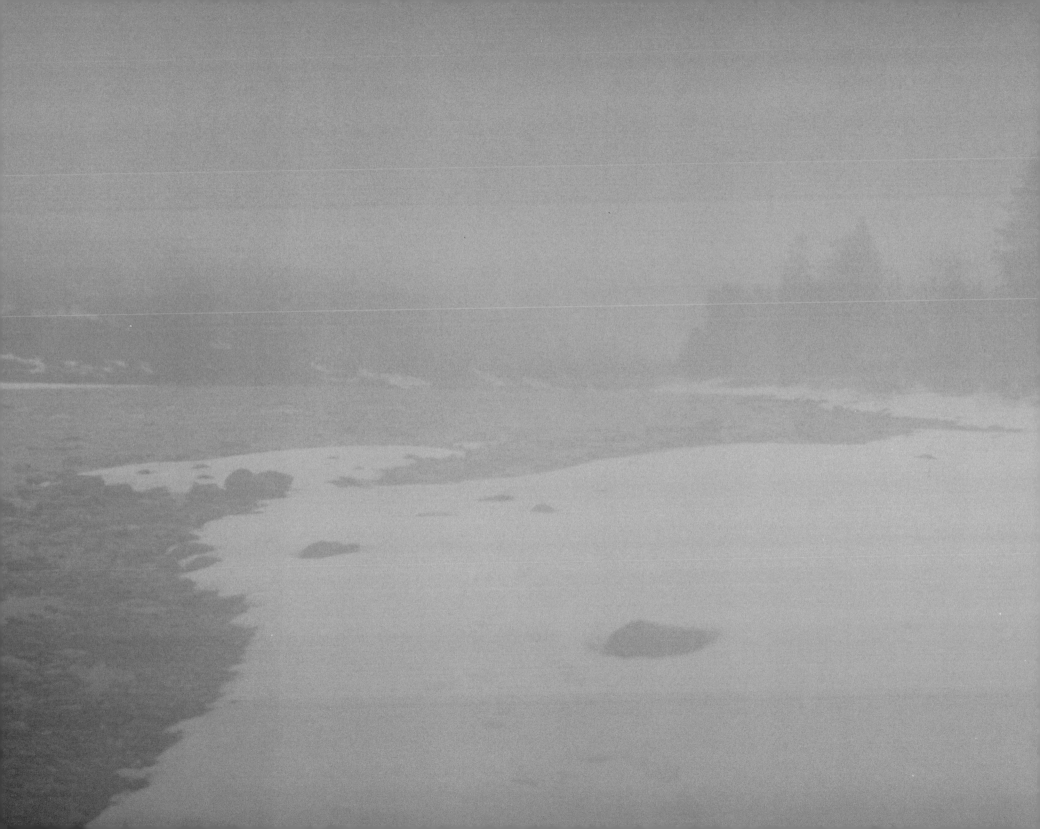

Luke Mogelson / Reflections on Hungry Horse

> "The rugged beauty of Northern Montana attracted rednecks and hippies alike. Both were eager to embrace the spirit of self-reliance its geography required."

Moving to Montana was the second thing Brad Lee Bruursema did after he graduated from high school: the first was spending fifteen days in jail for drinking and lying to a judge. As soon as Brad was released, he grabbed his backpack and guitar and hit the road. He hitch-hiked down to Texas, over to California, and on up to Oregon — but his destination was always Flathead Valley, a wild patch of country abutting Glacier National Park, high in the Rockies, where the last American towns gave way to woods and mountains. Ever since he could remember, while growing up in Holland, Michigan, Brad had heard his older brothers, Buzz and Randy, talk about the moose and elk they'd killed during hunting trips in Flathead with their father. Brad was five years old when he first went himself, and even then he had the same feeling his mother's people must have, a century ago, when they quit their sod huts on the Dakota plains, fled the Sioux Uprising, headed west, and laid stakes in that hard land. "Once you get here," Brad explained, "you want to be here all the time."

He was thirteen when his father, a builder, died of lung cancer. In her grief, Brad's mother, who'd never boozed or pilled before, took to both. With Randy off at college, Buzz in Vietnam, it fell to Brad to look after the youngest Bruursema, Tom. He did that for a year, until one morning he found their mother wedged behind a cabinet in her bedroom closet. "We say she died from heartbreak." The valium and vodka were incidental.

An aunt and uncle adopted Tom, but as Brad

said, "Nobody could put a rope on me." That very summer, he hitch-hiked out to Flathead on his own, and when he got back to Michigan, he evaded foster parents and the state, staying sometimes with friends, sometimes in his sister's basement, sometimes with Randy at the University of Wyoming. By now, his trustiest companion was his Gibson J-50 Deluxe. His father had bought him his first guitar at a garage sale when he was nine, and during the last few years that his parents were alive, they'd entertained the hell out of themselves: Brad strumming and them singing (Brad's mother angelically, Brad's father terribly). He'd written his first song at age twelve, after his father was diagnosed. It was called "You're Gonna Grow Up and You're Gonna Die."

When Brad moved out to Flathead after high school, he continued making music — at parties, in the park, on the front steps of Norm's News in downtown Kalispell — but he never took his talent too seriously, not in those days, anyway. With their inheritance, Brad and Randy bought twenty acres of raw land. They built a cabin for Randy and his wife out of trees they felled and peeled themselves, on a foundation of cobbles they prized out of the river bottom. All Brad needed was a teepee, which he fashioned from sheets of canvas wrapped on a frame of lodgepole pine. He put a stove in the center, ran its chimney straight up through the top. Still, the winter was brutal, even for a kid from Michigan. Some mornings, Brad would wake up to find the cows from a nearby ranch pulling out the hay he'd stuffed around the base for insulation. He'd have to fetch a piece of kindling, whack them on the nose.

This was 1976, and Flathead Valley, like the rest of the country, was far from a unified community. The rugged beauty of Northern Montana attracted rednecks and hippies alike. Both were eager to embrace the spirit of self-reliance its geography required. That didn't mean they got along. The loggers were the worst. If they saw you thumbing, they might try to run you off the road — or to run you over, who knew which. Sometimes, when they got their hands on a hippy, they pinned him down, cut off his pony tail and hung it up above the bar. Brad had long hair, but he was adept at navigating both sides of the cultural divide. His whole life he'd been caught in the middle. While Randy had been a committed activist protesting the Vietnam War, Buzz had served as a door-gunner and come home full of shrapnel and anger. The brothers no longer talked to each other — but they talked to Brad.

In any case, Brad Lee mostly avoided people. He enrolled in a zoology program at Flathead County Community College, but he often skipped classes to hang out at a camp on the middle fork of the Flathead River, counting salmon, bears, and eagles for Montana Fish and Game. When he wasn't working or in school, Brad was in the woods: backpacking in Glacier (twice all the way to Canada on the Highline Trail), snowshoeing, fishing for trout, hunting deer to butcher and fry up on the stove.

It was an invigorating life, but lonely, and after two years in the teepee, Brad returned to Michigan for Christmas. There he met, got pregnant, and married a woman named Pam. Brad's plan was to bring her back to Flathead; Pam, however, turned out to be the type of person who never strayed too far from home. They had three sons together. Working as a contractor and a deckhand on boats around the lake, Brad somehow found time to keep playing music on the side, and to bring his boys to Montana every summer he could manage.

One day, after performing at a bar on the south side of Holland, Brad was approached by a stranger and asked had he written all those songs he'd just sung? If so, did he have a tape? It was winter, Michigan, and the only tape Brad could find was frozen into a shallow puddle of water on the passenger-side floor of his truck. He had to turn the engine on and let the cab warm enough to melt the water before he could pry it free. The stranger waited, and two weeks later Brad received an invitation from a studio in Nashville. Thus began a kaleidoscopic chapter in the biography of Brad Lee, during which he oscillated almost weekly between two very different lives: one in Michigan, running a construction company, raising three boys, being a husband; the other in Nashville, recording songs, courting backers, gigging. Something had to give, and eventually he and Pam separated. Brad continued touring and pushing albums — he knew this was it, he wasn't going to get another chance — and, at the

> "There were no fast-food franchises, no big-block retailers, and no noise. There was nothing at all, really, except you and the trees."

turn of the millennium, when Universal Records Texas and various independent radio promoters nominated him for five Grammies, including Best Country Song and Best Country Album, the way at last seemed clear.

Then, just as sudden, it was gone.

During the first couple of concerts he performed after his nominations, Brad had difficulty hitting the high notes. He saw a doctor, who told him he had throat cancer. After they removed the tumor from his vocal chords, Brad couldn't talk at all for almost two months. When his voice finally did come back, it wasn't the same. More fatally, in an already unforgiving industry, he'd become a liability. "Guess what happens when you get cancer on your vocal chords? People stop investing money in you." Brad went back to Michigan and started drinking heavily. "Things got bad. I went from beer to whiskey, whatever I could find. I was miserable, fucked up all the time. It goes downhill from there."

It went downhill for a while — about five years. It was February, 2006 when Brad decided to kill himself. Three days earlier, he'd woken up hungover, stumbled into his garage for a cigarette, and found the snow plow on his truck smashed and bent beneath the chassis, bits of glass from someone else's windshield scattered on the hood. He called the police and asked if there'd been any accidents. He watched the news. He was ready to turn himself in. He was six feet, four inches tall, and he weighed 144 pounds. He was living on V8, getting out of bed and pouring rum into his coffee, puking it up, pouring another.

He decided to get sober. He was resolved to. After a couple days, however, Brad knew it wouldn't take. He called his friend Kenny and asked him to bring over a bottle. "I thought I'd just have a little bit," Brad said. "That bottle disappeared. I was so mad that I couldn't quit. I thought: 'The kids don't need me anymore. I'm not gonna let this beat me.'" Brad loaded his revolver. There was a creek at the back of the property — he would go down there, so as not to make a mess in the house.

Back in 2000, the year of his cancer and Grammy nominations, Brad had adopted a stray puppy named Trapper — since then, that dog had never once left Brad's side. On his way to the creek, Brad filled Trapper's water bowl at a faucet on the deck. As Brad was coming down the stairs with the bowl, Trapper ran underneath his legs and tripped him. He'd never done anything like that before. Brad fell against the railing and blacked out.

When he came to, Brad found himself engulfed in a roaring whiteness. The whiteness surrounded him, buoyed him, until again he lost consciousness. The next time he opened his eyes, he was in a hospital bed, his arms strapped to the frame. The whiteness, a doctor informed him, had been an M.R.I. machine.

As soon as Brad was discharged, he went to Kenny's and started drinking. That's where his three sons found him, a few hours later. Almost killing himself hadn't been enough, but when Brad's boys showed up at Kenny's and told Brad they loved him, he was ready. They drove together to a treatment center in Grand Rapids, where Brad stayed for the next thirty days.

When he got out, Brad started attending AA, and over time he met and fell for another alcoholic, Lin. He'd been drawn to her instantly — most of all, to her kind eyes and her sense of humor, the way she could crack him up. But also, Lin was no Pam. She was as adventurous as Brad, loved to travel, loved the woods. She was up for anything. The summer after they met, Brad brought her out to Flathead and they ran the river on a float trip. Lin was enchanted by the place — she just got it. The following year, they both packed all their stuff into a camper trailer, pulled onto I-90, and said goodbye to Michigan.

In South Dakota, they turned off the highway at Wall Drug and wandered around the 80-foot Dinosaur, the mechanical Cowboy Orchestra, the Pharmacy Museum. At some point, they saw a sign that read "Get Married Here" and next thing Brad Lee knew they were standing in front of a Western-style background painted on a sheet of canvas, and the local sheriff was pronouncing them man and wife. When they got to Flathead, they rented a little cabin up the road from the entrance to Glacier, not far from the river and the train tracks that paralleled it, in a place called Hungry Horse. (Brad and Randy had sold their twenty acres after Brad married Pam.) This tiny section of canyon — it wasn't even a town, technically — was home to a few bars, gas stations, lodges, and guiding outfits that catered to park visitors during summertime, as well as a small community of year-rounders who were, in general, more free-spirited, rough-hewn, independent-minded, and poorer than their neighbors in Kalispell or Whitefish. One couple kept a pet bobcat in their backyard, and a local saloon featured a mounted deer head licking the anus of a mounted deer rump. There were no fast-food franchises, no big-block retailers, and no noise. There was nothing at all, really, except you and the trees. For Brad and Lin, it was perfect.

Up the road from their place was a gas station and cafe called Gas Station and Cafe, owned by Robert C. Johnson, better known as Bob, a kindly old vet who'd lived in the valley since 1972. Originally from Wisconsin, Bob had enlisted in the infantry at seventeen and been shipped to Korea one year later. He spent eighteen months in that hell hole, twelve of them sharing a cramped bunker made of rock and logs with six other grunts and a .50 caliber machine gun. Every day, they'd get pounded by mortars, dodge sniper fire, conduct ambushes, melt snow in their helmets over a five-gallon bucket of charcoal in order to bathe, and struggle to ignore the bugle that the North Koreans in the opposite trench blew nonstop just to keep them frazzled. Four of Bob's six comrades were killed — but he made it back as a non-commissioned officer, finished out his contract with the Army at Fort Indiantown Gap, Pennsylvania, returned to Wisconsin, and landed a job at a paper factory in Rothschild.

He worked there twenty years. After the first year, Bob was given one week of vacation; after five years, he got three weeks; after fifteen, a month.

> "Today, Hungry Horse remains a place of second chances — sometimes miraculous ones — where wounded or hurting or enfeebled people come back to life, are healed and restored."

Most of this time he spent in Montana, with his wife and three sons. One of Bob's old Army buddies lived in Flathead, where he worked for the Forest Service, and after Bob visited him one summer, he never went anywhere else. When he retired from the paper factory, Bob moved his family out to Hungry Horse and bought an old store and gas station in nearby Corum. Mountain life didn't suit Mrs. Johnson, and six months later she divorced Bob, moved back to Wisconsin. Bob and the boys stayed. Between the tourists and the locals, he was pumping a tanker of gas a day and still had time to hunt and fish. In the winter, he'd head to the lake every chance he got. He could sit out on that ice all day. It was cold — but nothing like Korea. And for Bob, there was no greater thrill than feeling one of those big rainbows hammer at your line, while you reeled it up, through the narrow hole, from below that frozen surface.

In 1979, the federal government, expanding the highway traversing Flathead Valley, exercised eminent domain to appropriate Bob's property. With the compensation, he purchased a small roadside lot, dense with trees, in Hungry Horse. He bought four steel tanks in Missoula, hired a friend with a backhoe to dig a pit, pulled the tanks in with a chain, back-filled the pit with sand, plumbed in a few pumps, and had himself another station. Piecemeal, as money came in, Bob and his sons expanded the shop and cafe, pouring the foundation themselves (mixing the concrete by hand), hanging the sheetrock, laying the tile. By the time Brad and Lin moved out,

in 2007, Bob had gone from selling cigarettes and candy to serving the best breakfast in town.

There's an old story about how Hungry Horse got its name that seems almost to have anticipated people like Brad, Lin, and Bob. According to the story, two freight horses, during the winter of 1901, wandered away from their sleigh in the Flathead River's South Fork area, and became lost in the wild. Their owners gave them up for dead, but after wandering for a month in "belly-deep snow" (in the words of the plaque not far from Bob's station), the horses turned up again, "almost starved and so weak considerable care and feeding were required before they were strong enough to be led back to civilization."

Today, Hungry Horse remains a place of second chances — sometimes miraculous ones — where wounded or hurting or enfeebled people come back to life, are healed and restored. Take Charlie Krasselt, who lives just up the road from Gas Station and Cafe. The youngest of nine children from a house that also accommodated sixteen foster kids, Charlie came of age spending his summers on the road, working as a lumper on refrigeration trucks, hauling produce and dairy throughout the northwest. He celebrated his twenty-first birthday in the gas chamber during basic training. For the two weeks of leave he was granted before having to report to his National Guard duty station in Vancouver, he decided to visit his big brother, another Bob, in Montana. Bob was ten years older than Charlie and hadn't really been around when they were young: he'd gone to live with an uncle in Wyoming, where he started breaking horses for a living and rodeoing for fun. By the time Charlie came out

to visit him in Flathead, Charlie said, Bob was "the quintessential cowboy. I never seen the man in a pair of shorts. Never in my life. If he was outside, it was cowboy boots, cowboy hat, belt buckle, the whole nine yards."

Charlie loved Montana — "the scenery, the people, the way you could walk down the road and look somebody in the eye, and they'd smile and nod at you" — and, he quickly came to realize, he loved Bob. All Charlie's life, everyone had only ever called him "Guy." The nickname dated back to his infancy, when his grandfather had once sat him on his knee and announced, "This is my little guy." Bob, though, refused to use anything but Charlie's given name, explaining, "You're a man now." Charlie's father, an alcoholic, had never been in the picture, and his mother, before Charlie joined the Army, had needed more care than she could give. Now, for the first time, Charlie felt as if he'd stumbled on the family and respect he'd always missed.

A couple months later, Charlie transferred to the Montana National Guard and moved into Big Mountain Trailer Park in Whitefish. He landed a job driving a delivery truck for a laundry, and on his days off he helped Bob hang drywall. When neither of them had to work, they headed for the woods, where Bob taught Charlie how to hunt and fish. Charlie shot his first deer in October, not far from Big Mountain, on the banks of Bong Water Creek. Bob spotted it for him, and after it went down, he showed Charlie how to gut it, right there in the snow.

One night, the two brothers went for a drink at the Silver Bullet Bar, and on their way in the door, they encountered what Charlie remembers as "a little short thing trying to get out." Her name was Cindy Agnew.

From then on, Charlie kept seeing her around the bars. Every time, he asked if she was single, and every time, Cindy said she wasn't.

About a year after Charlie first met Cindy, Bob got cancer. Although the doctors gave him three months, he hung on for another two years. One day towards the end, Charlie gave Bob a ride home from a chemo session, and they arrived at the house to find all of Bob's belongings neatly stacked in the yard. His wife was leaving him.

Charlie rented a cabin in Hungry Horse, where he lived with his brother until he died, taking care of him and coordinating with the hospice nurses who visited every day to attend to the morphine pumps that kept the pain at bay.

Charlie stuck around the valley after Bob died, and a few months later, he ran into Cindy Agnew again. This time, when Charlie asked if she was single, Cindy said she was. Shortly thereafter, he moved out of his trailer, into hers.

They're still in Hungry Horse today. ("We never actually got married," Charlie said, "but she is my wife. We don't need no paperwork.") They live in a proper house now. Cindy works at a Burger King in Whitefish, and Charlie's the head maintenance man for a complex of shops, restaurants, and lodges in West Glacier. He still finds peace in the woods Bob introduced him to, and everyone still calls him by his name.

When Brad Lee returned with Lin to Montana, it felt like they were both being given a new lease on life. They were in love, they were in the Rockies, and they were sober. Brad reached out to his connections at the bars and lodges, and started performing again. He wasn't going to be a big star, that ship had sailed, but it didn't matter. He was happy just to play.

They'd arrived in November, and in February Lin went to the doctor with a stomach ache. She was diagnosed with uterine cancer on Valentine's Day. Two weeks later she was dead.

Brad had never suspected that the cancer was terminal. But he thinks Lin might have. He thinks this because after she died — after Brad had her cremated, after he found himself alone again, after everything was gone, his best friend gone, and after he was at a complete loss as to what to do next — he began receiving messages from an online dating service. At first, Brad ignored or deleted them. But they kept coming — every week, every day. Not only that, the messages often included strangely specific information about him, personal information.

"Come to find out," Brad recalled, "Lin had signed me up. She was pretty computer savvy. All this stuff was filled out. My profile was filled out. She had done this — Lin had. She didn't want me to be alone." For a long time, the possibility of another woman after Lin was unthinkable. But eventually, he gave it a go. It was what Lin had wanted, after all. He struck up an email correspondence with a woman named Louise Turner, who worked for the corporate offices of SkyWest in St. George, Utah. "After a while," said Brad, "you get to a point where you can ask for a phone conversation. So we started talking a couple times a week. She told me about her past, I told her about mine." Louise had recently been divorced from her husband of twenty-one years. She'd wanted to visit Montana ever since she was a little girl, and when it felt right, she did fly up. Brad met her at the airport and drove her straight to Glacier National Park. It was a kind of test. "We had great time," he said. "Just a great time. We got along real good. She likes the woods." He was wary, still reeling from the loss of Lin, and by no means anxious to get involved in a new relationship. But there was no denying it: Louise was an extraordinary companion. One thing led to another, and after requesting a transfer from St. George to Kalispell, Louise joined Brad Lee in Hungry Horse.

They're still there, too. They hike a lot in the summer, snowshoe in the winter. Brad's still sober, and he still plays the guitar, often with his dog Trapper, who turned fourteen this year, lying at his feet. Sometimes, deer wander out of the larch grove out back, stalk up to the window, and listen.

They patronize Bob's Cafe and Gas Station on occasion. Inside, Bob still mans the register. A couple years ago, while shoveling snow out back, he got frostbite on his left foot and had to have his big toe amputated. That put an end to his ice fishing career. Then his knee gave out while he was shingling the shed roof. Then there were the bone spurs on each shoulder. And finally, Bob's gallbladder had to be removed. It was a tough year, but Bob was back at the station, working dawn-to-dusk days, as soon as he could stand.

It might be easier living somewhere else — but easy is seldom what people who come to Hungry Horse are looking for. "It's a humbling place," Brad Lee has said. "These mountains are so big, this wilderness is so big — it makes you feel small. You look around here and it opens up your eyes. You can't understand it unless you come here and see it." 🐎

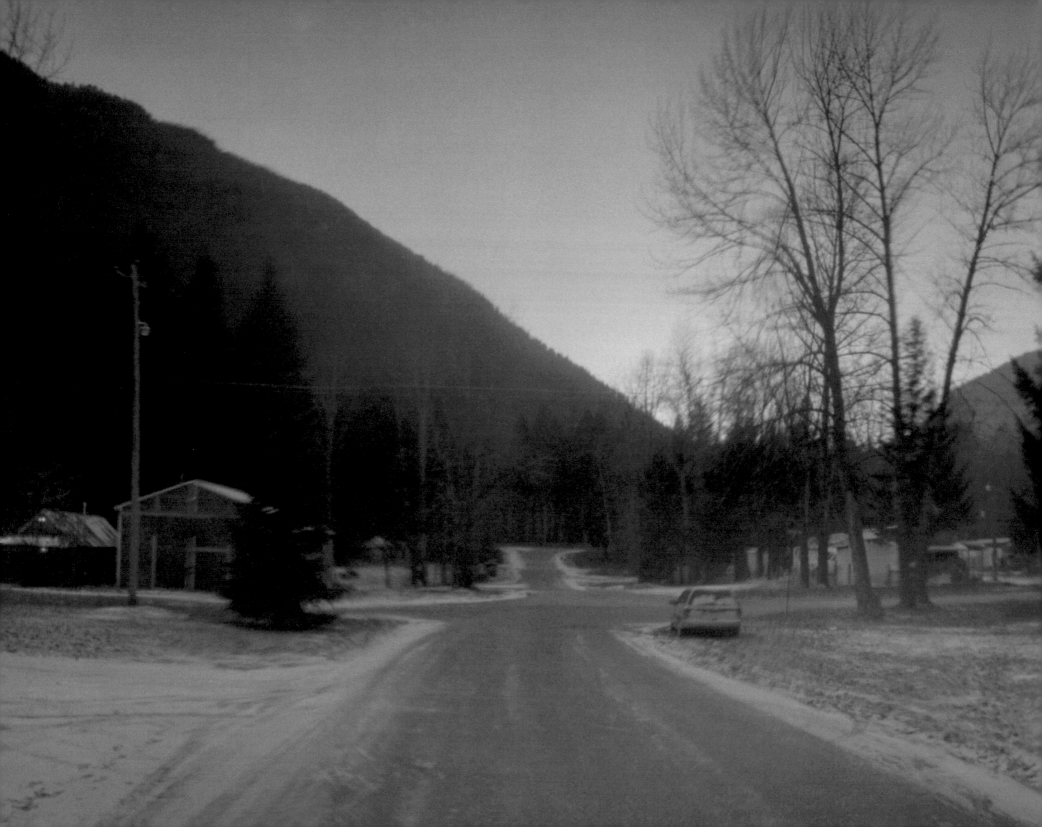

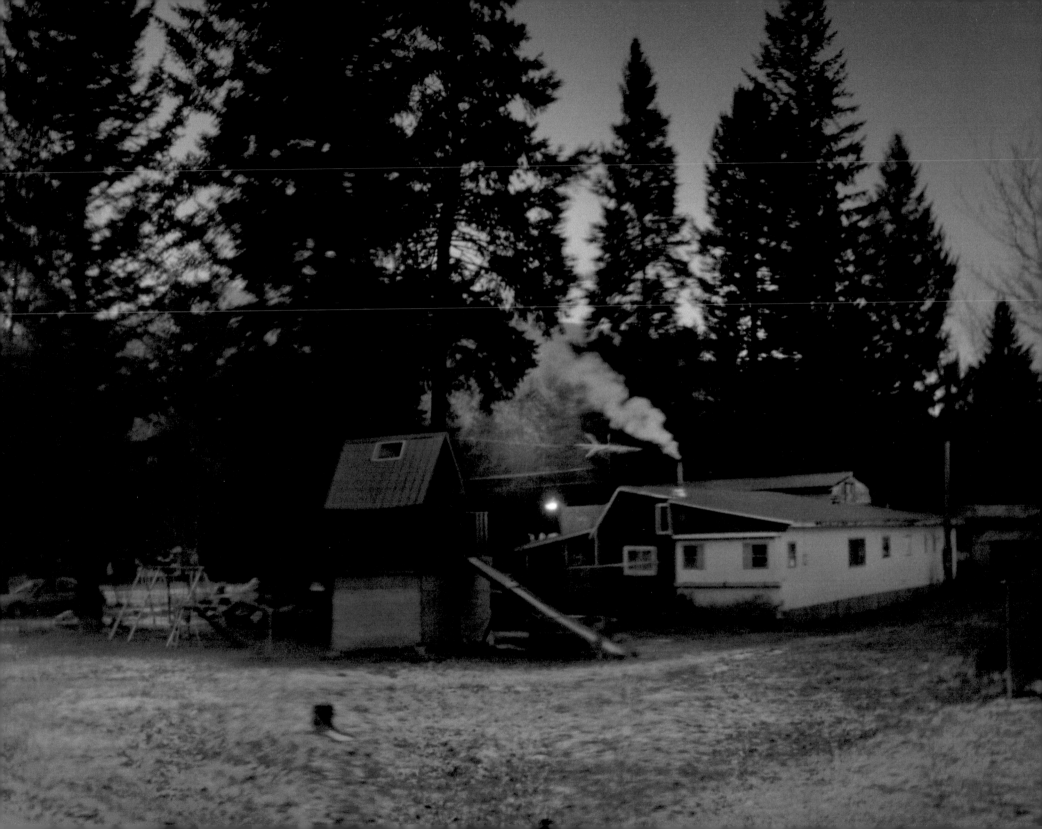

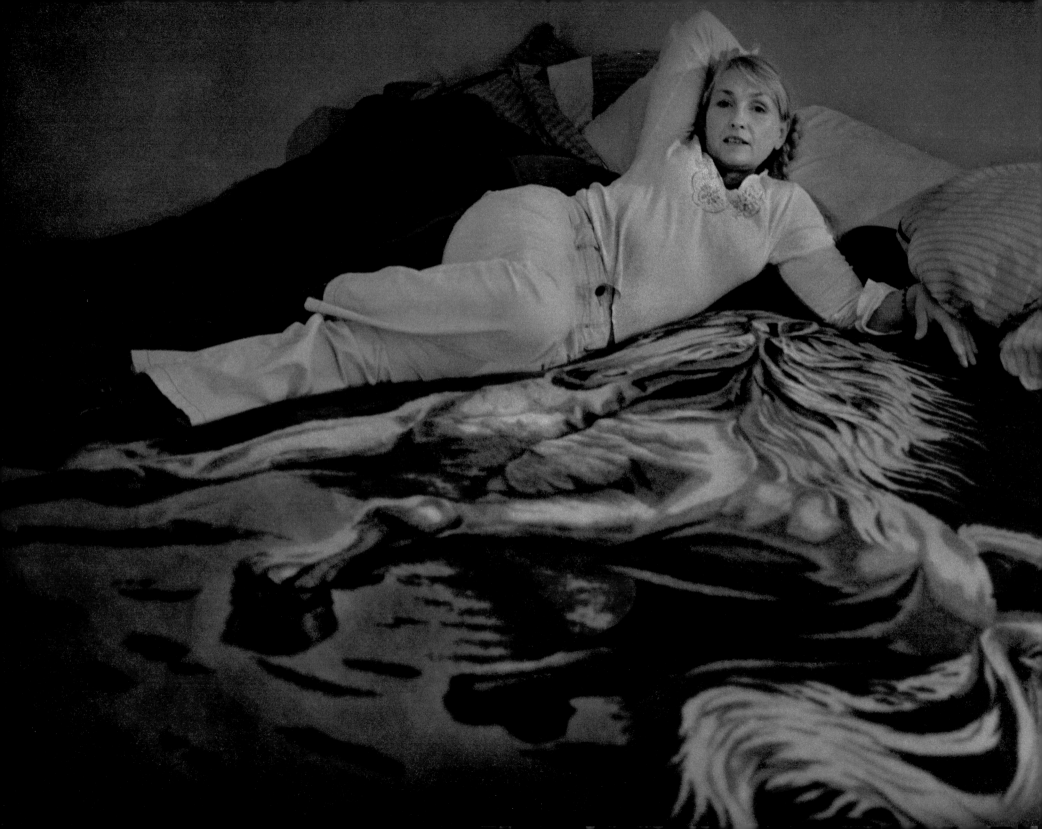

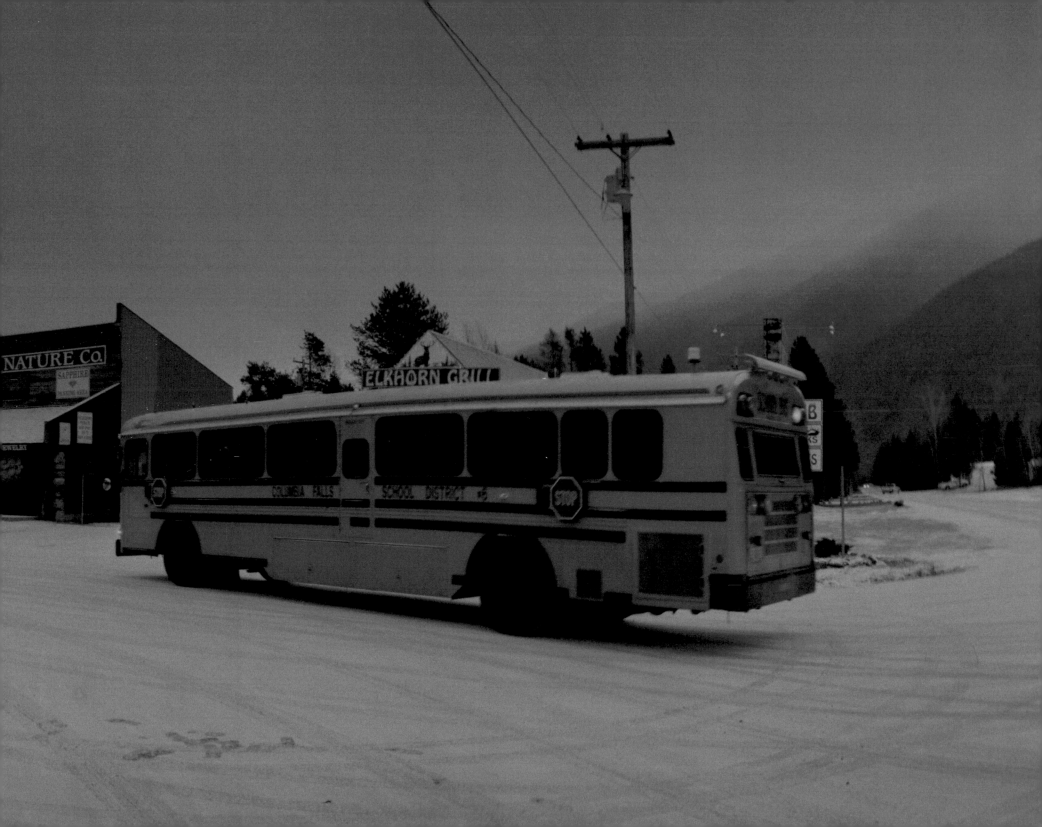

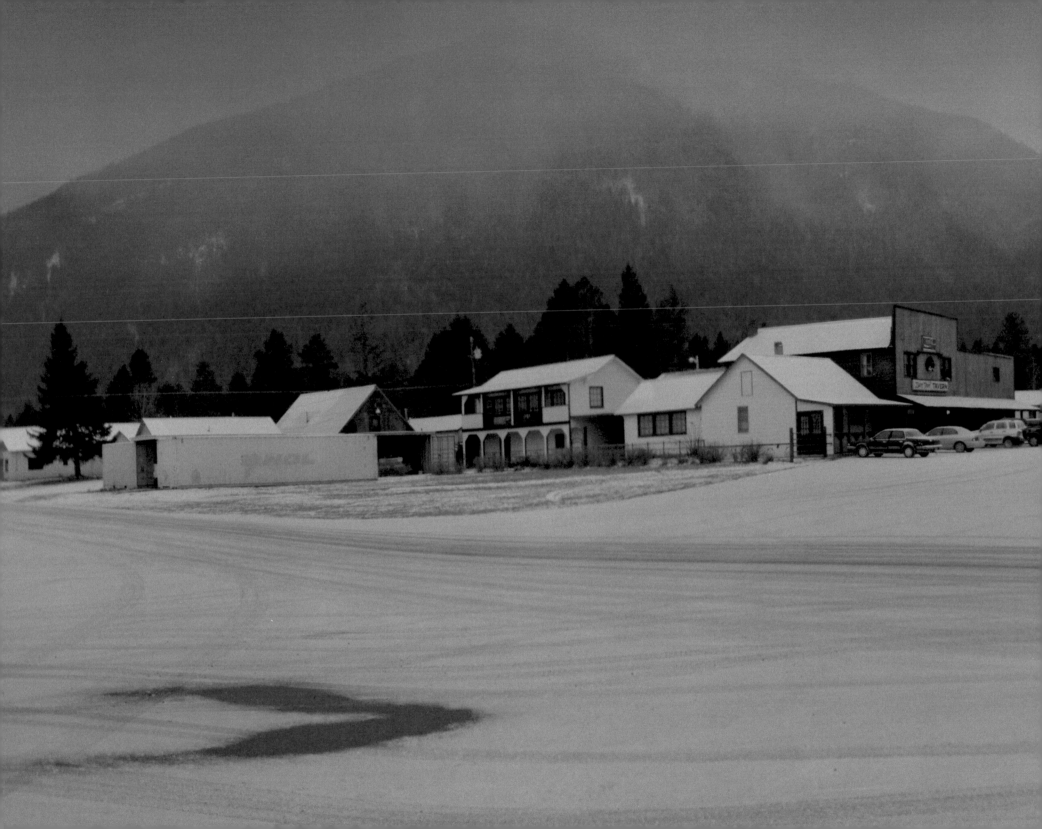

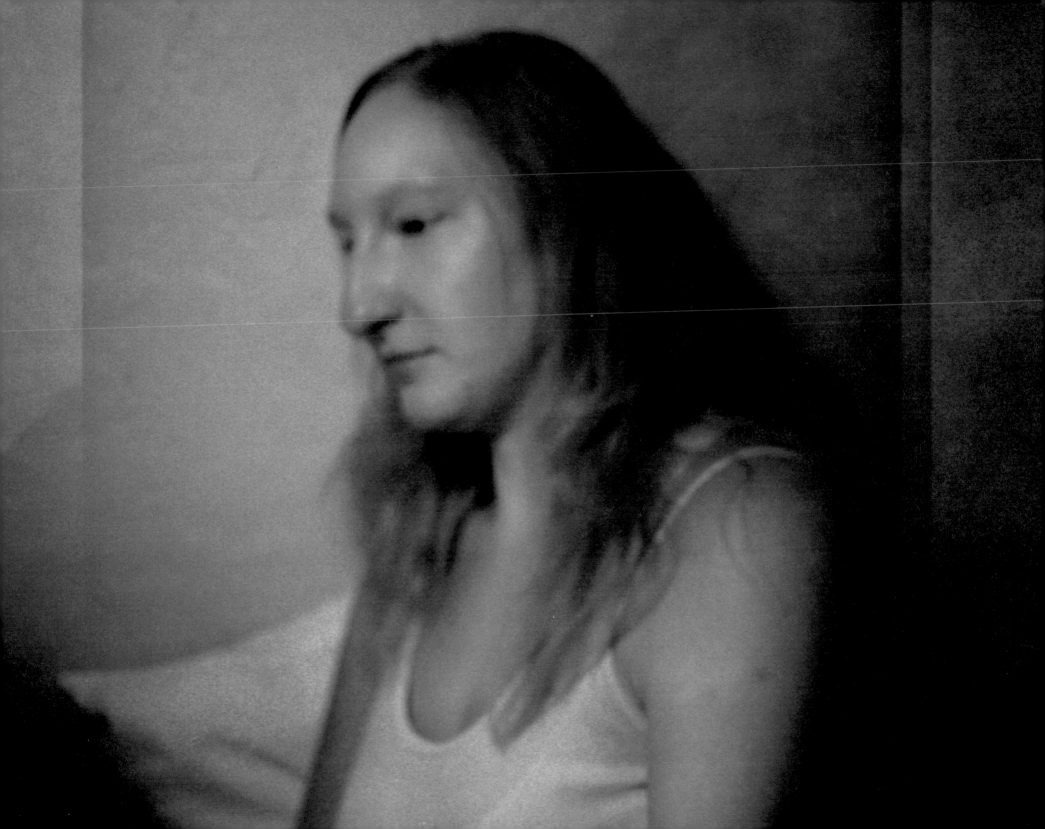

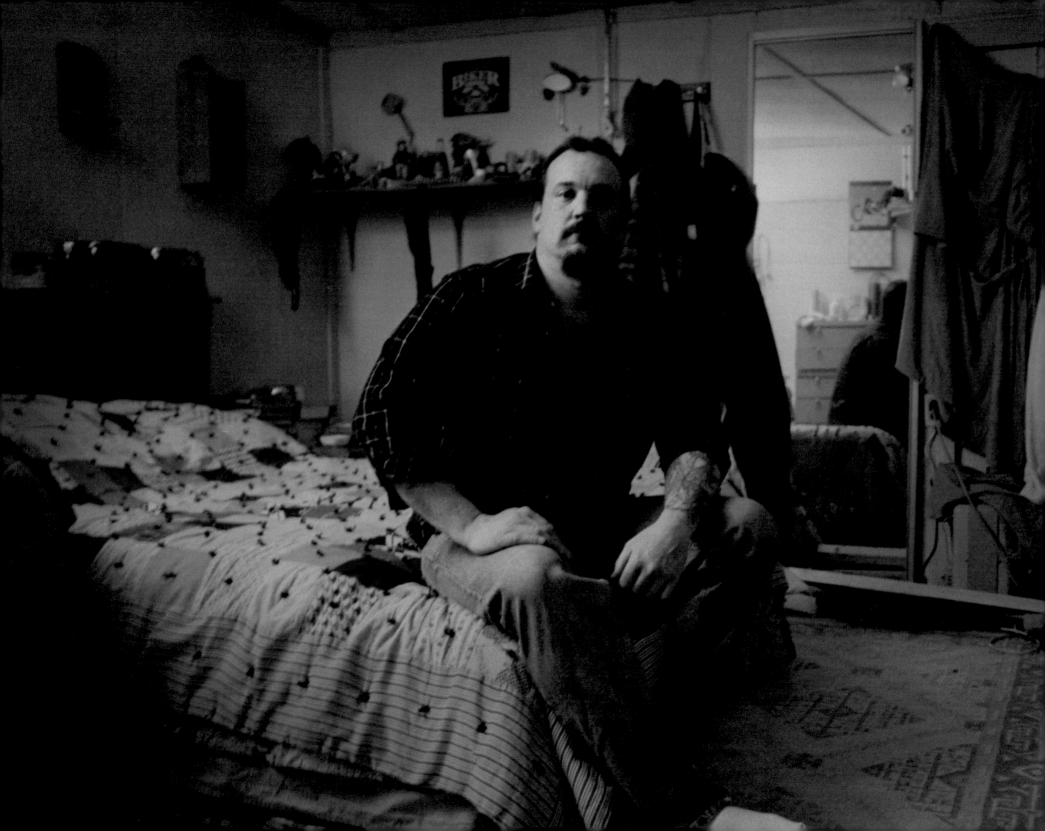

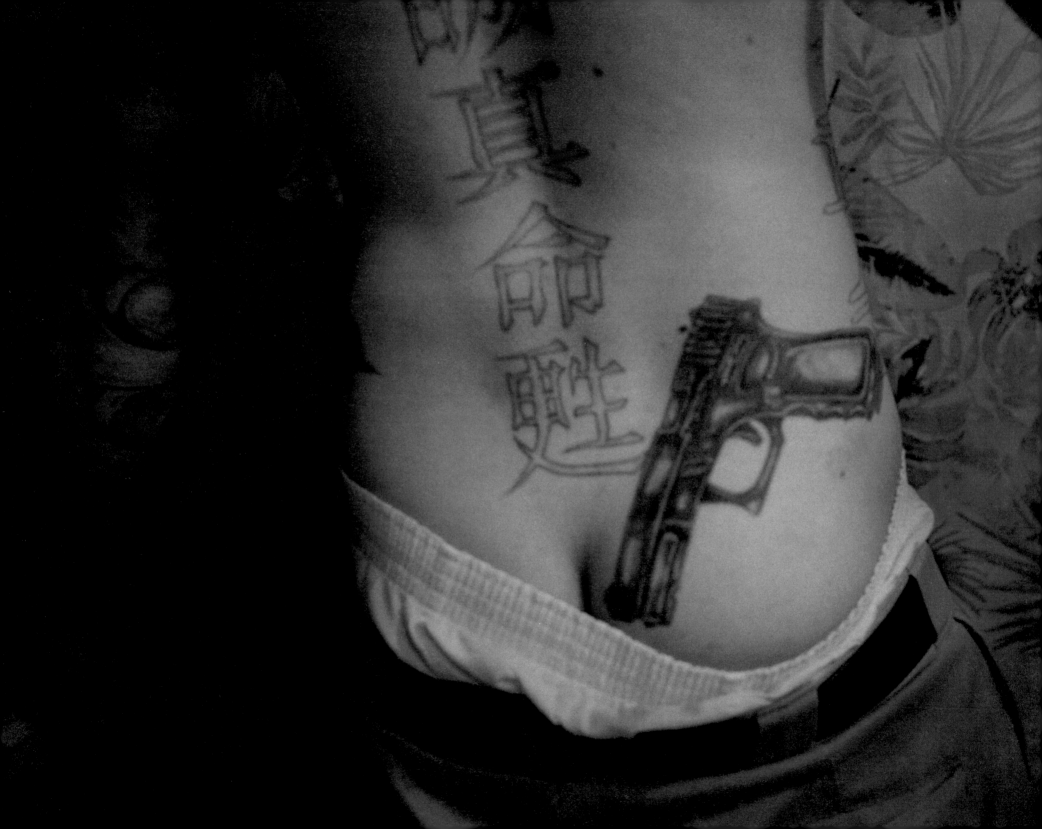

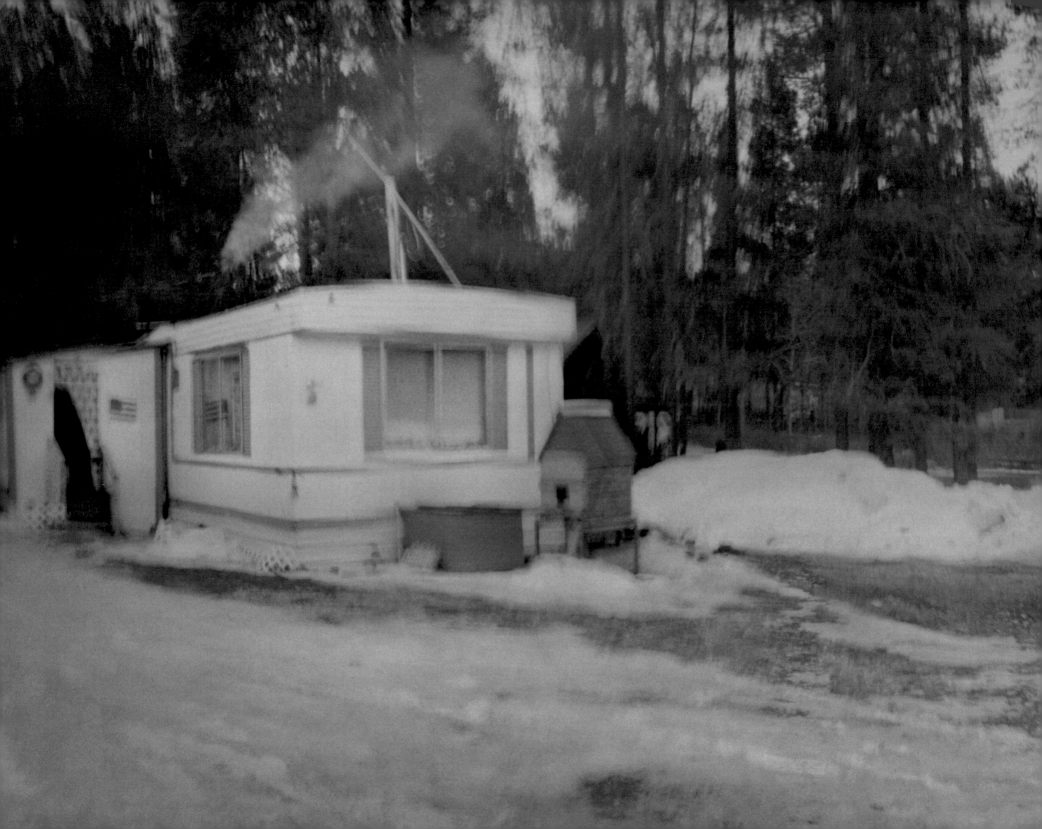

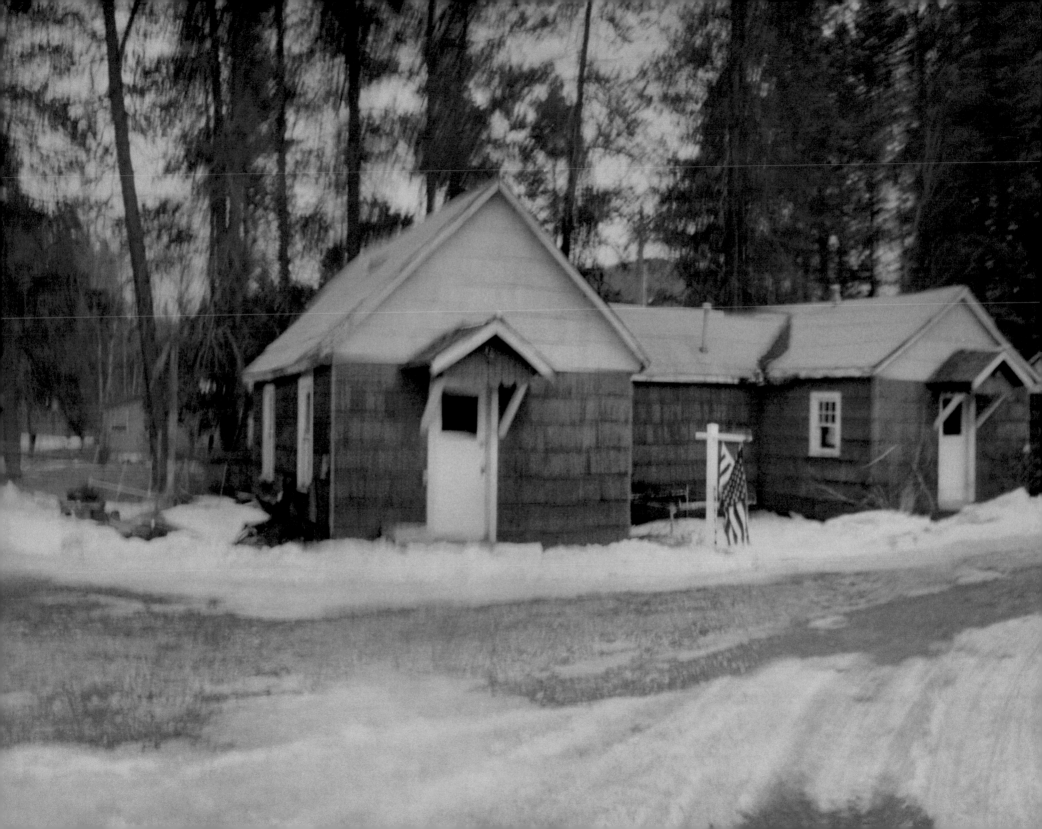

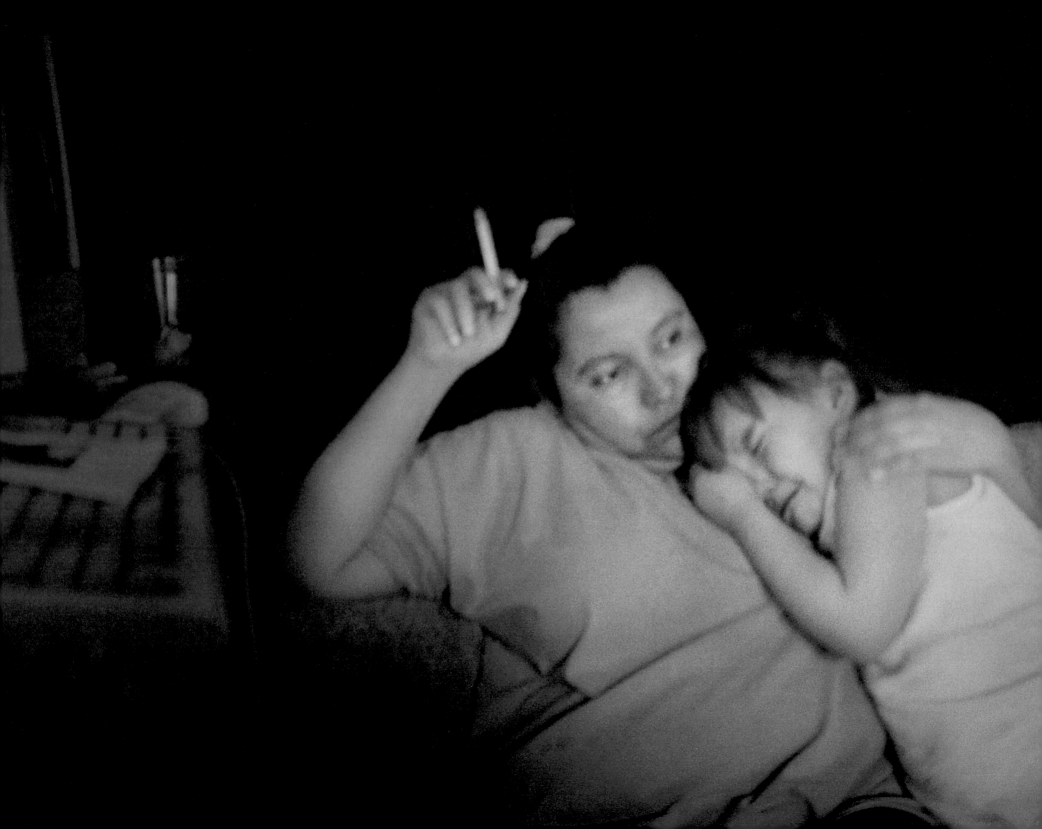

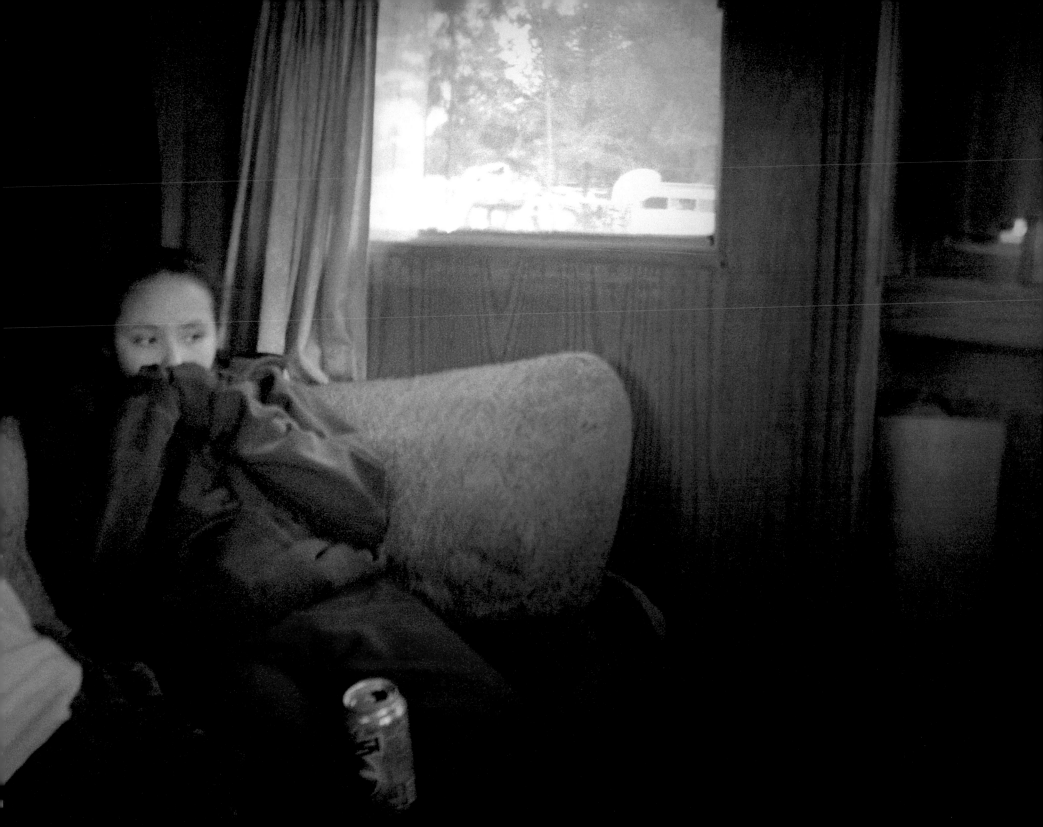

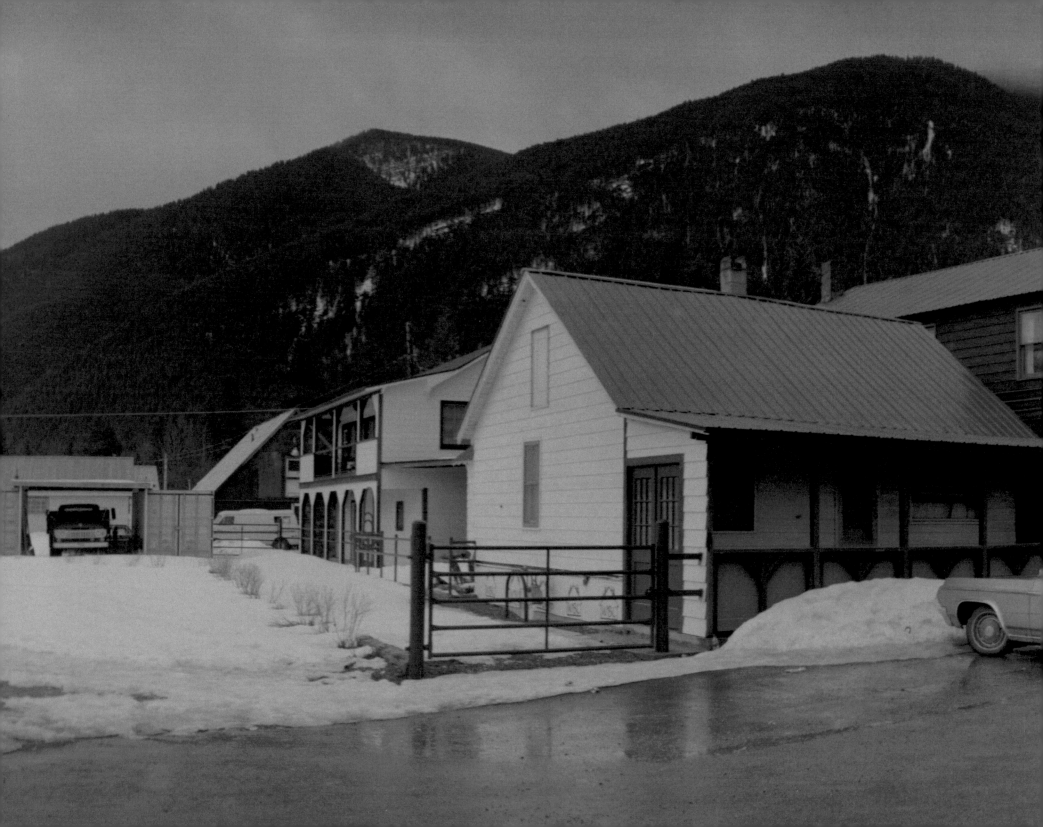

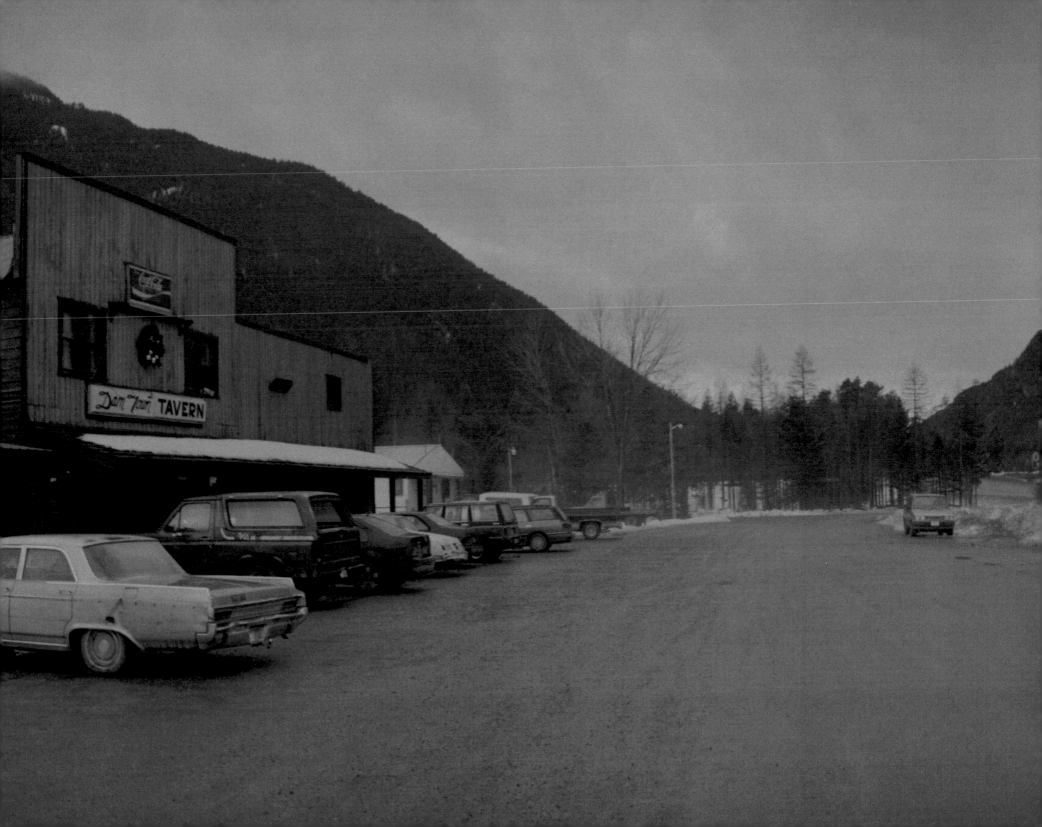

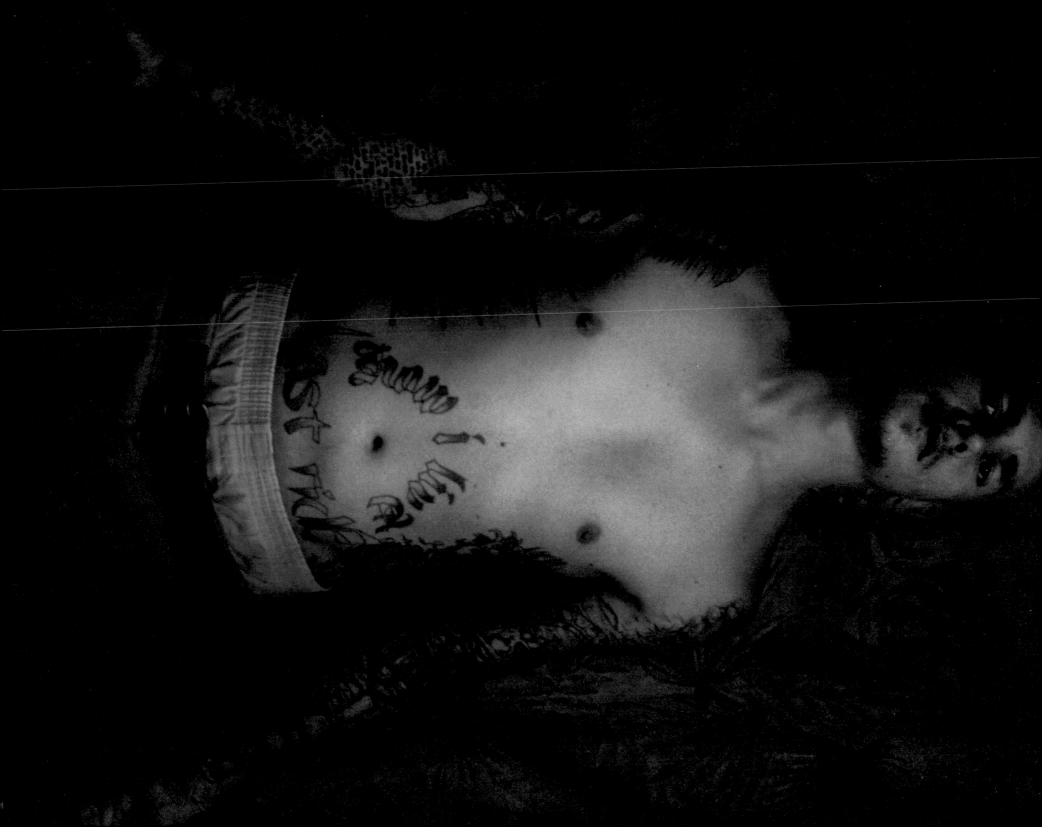

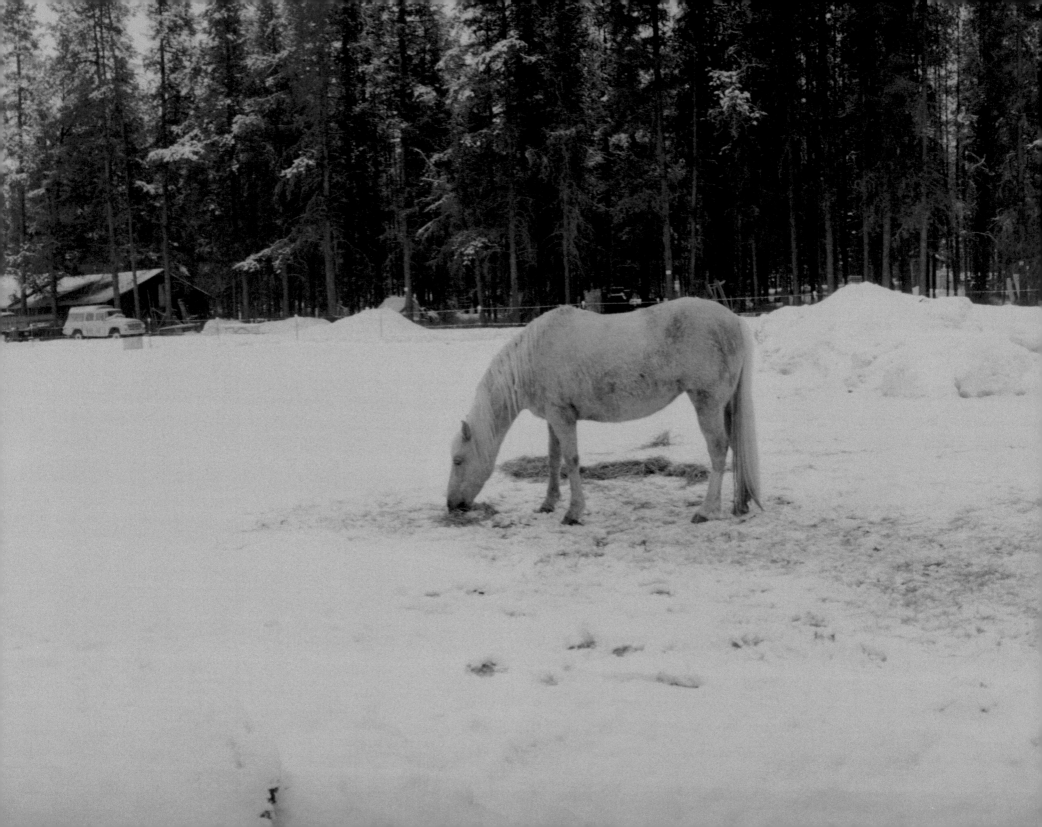

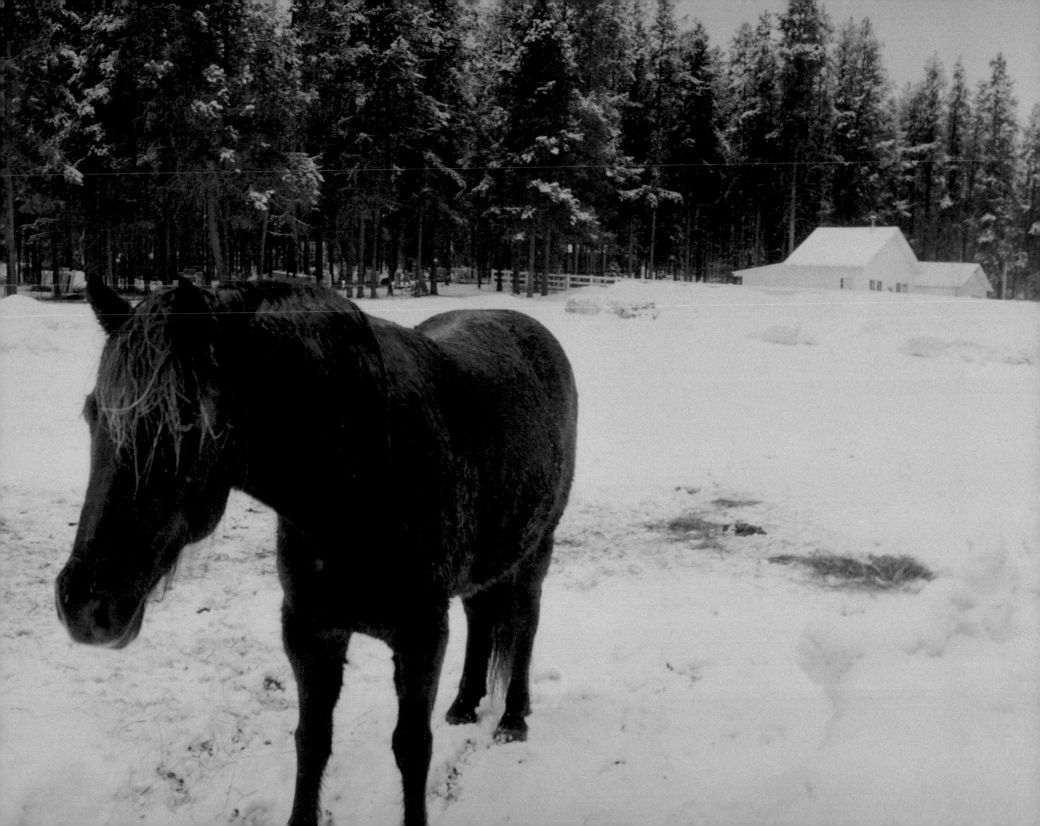

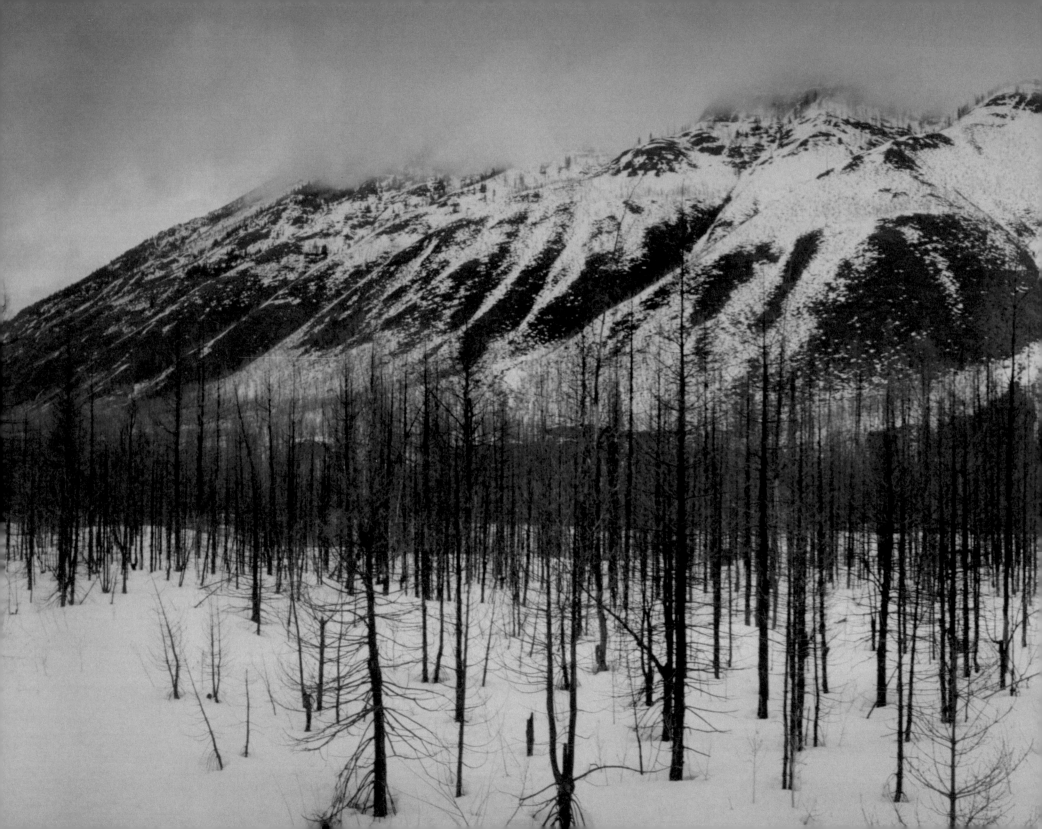

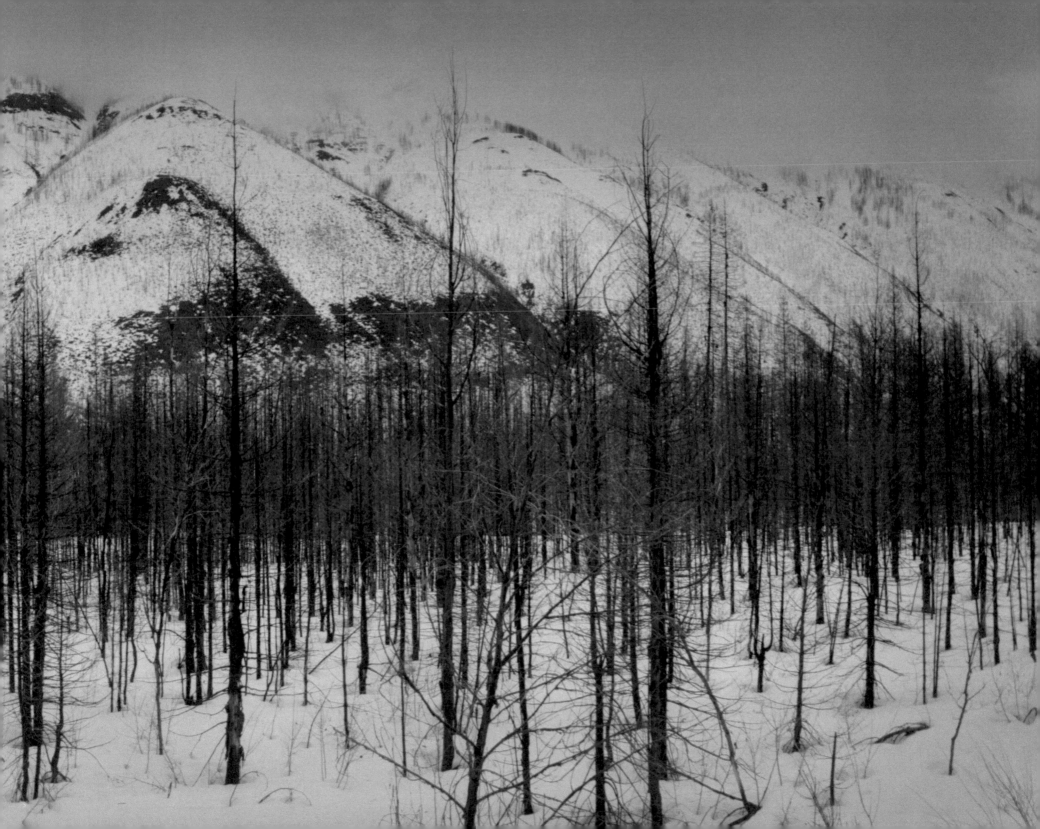

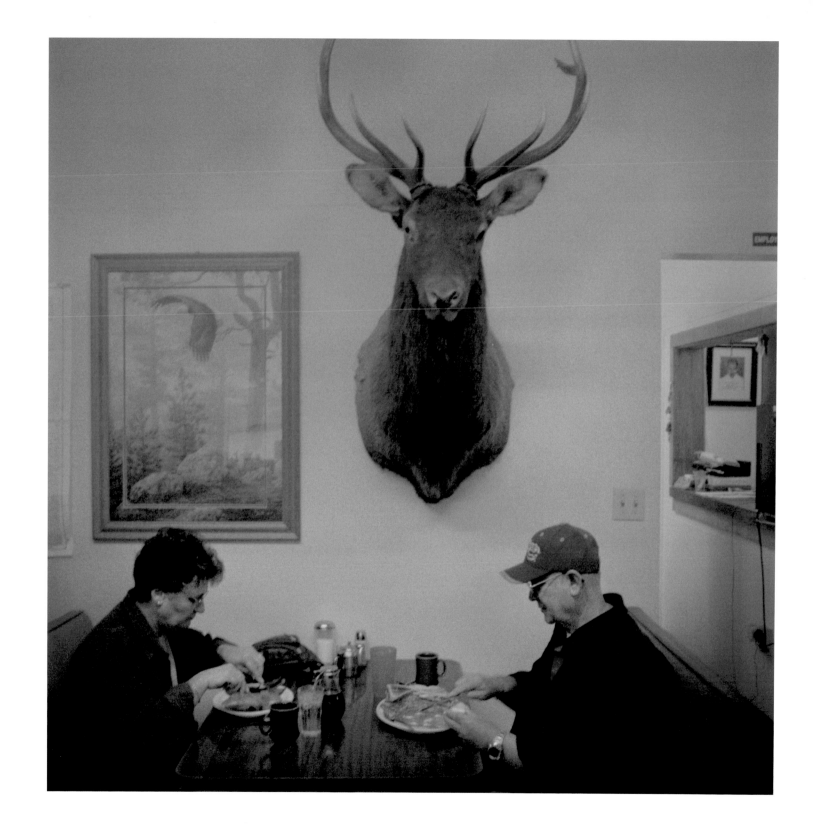

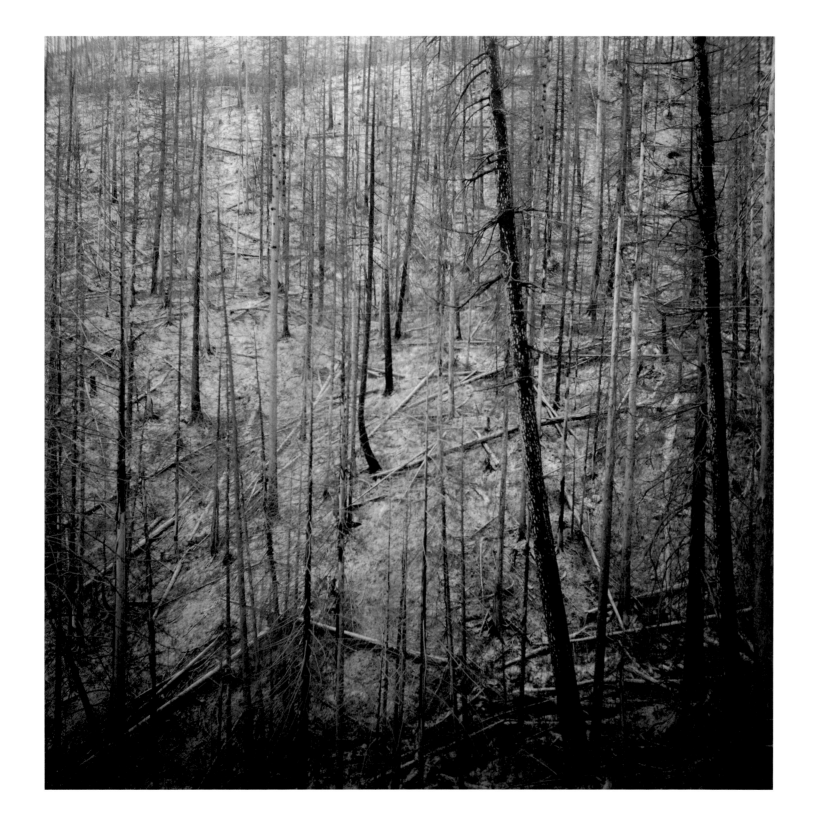

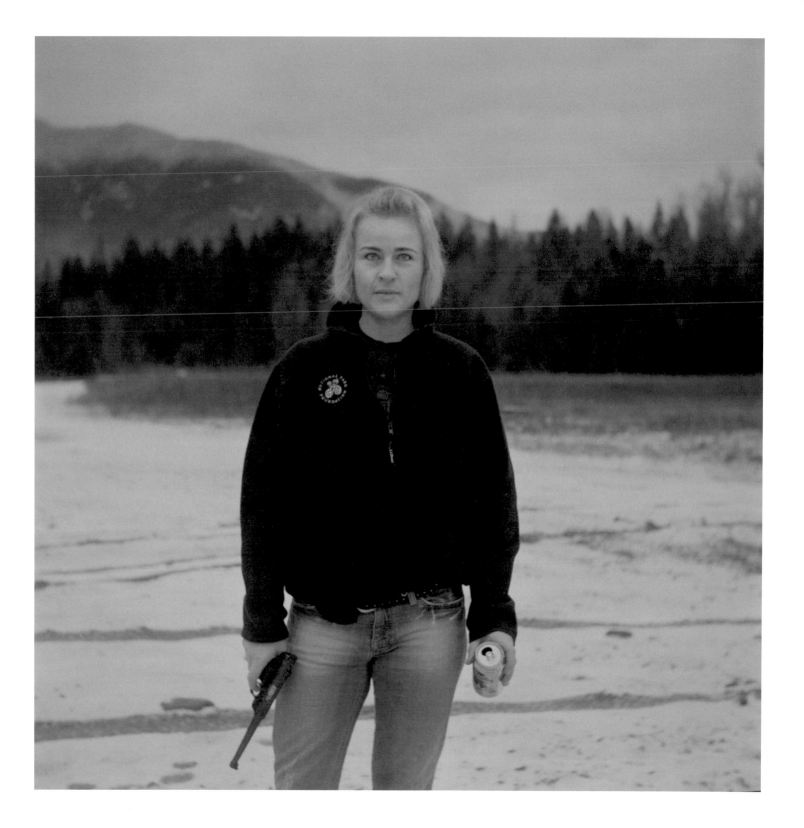

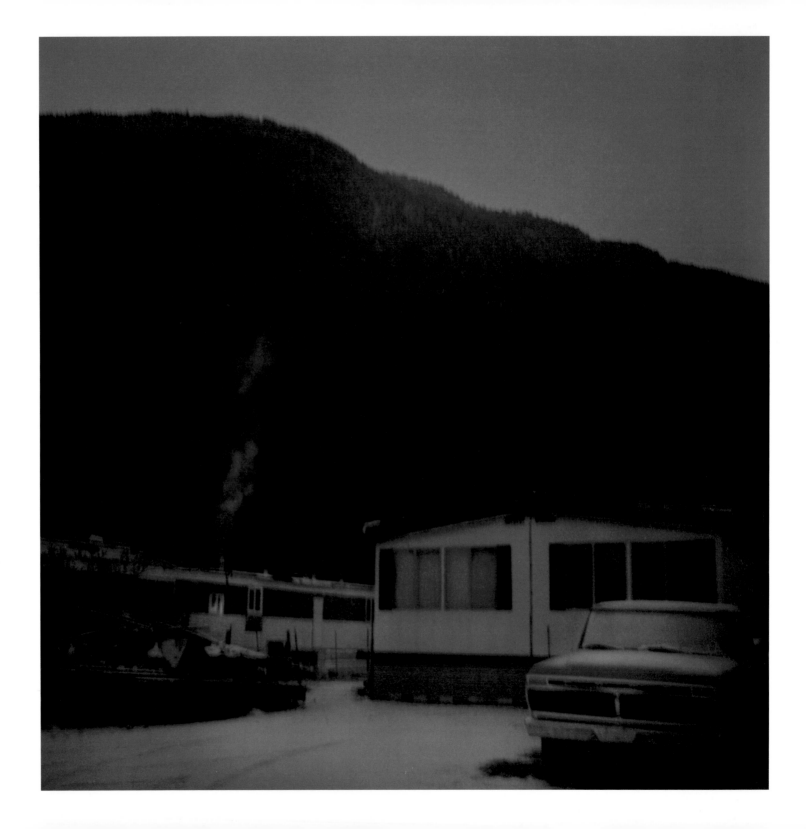

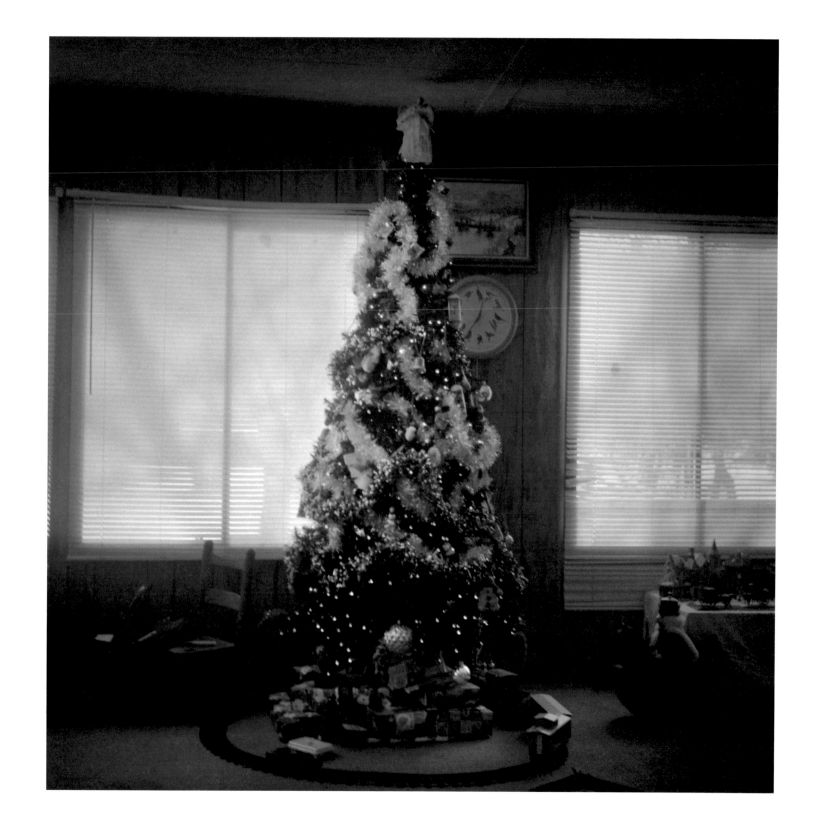

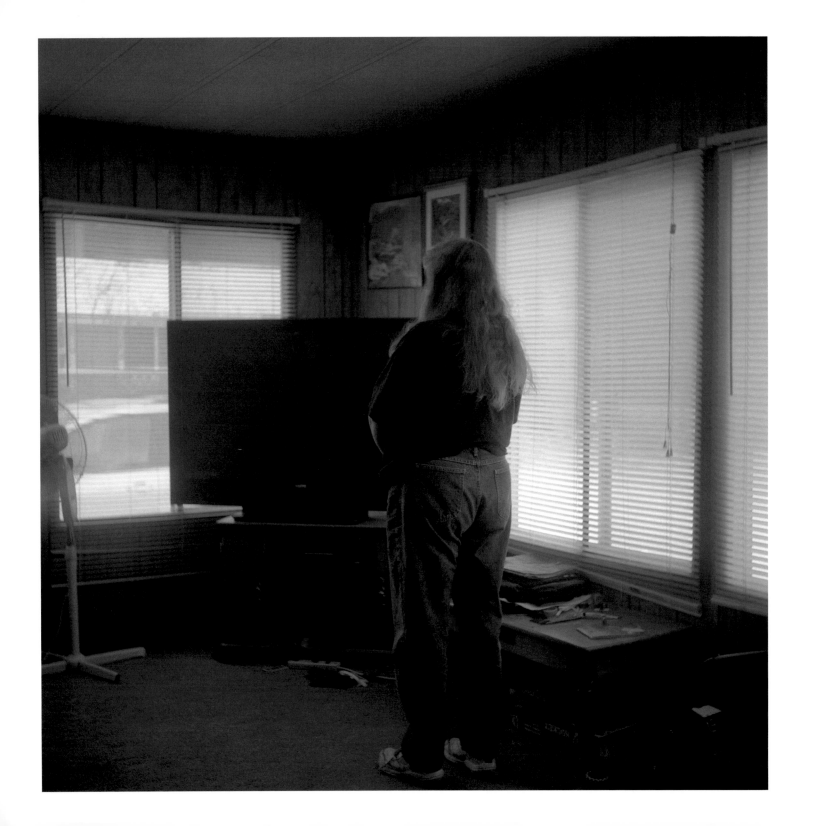

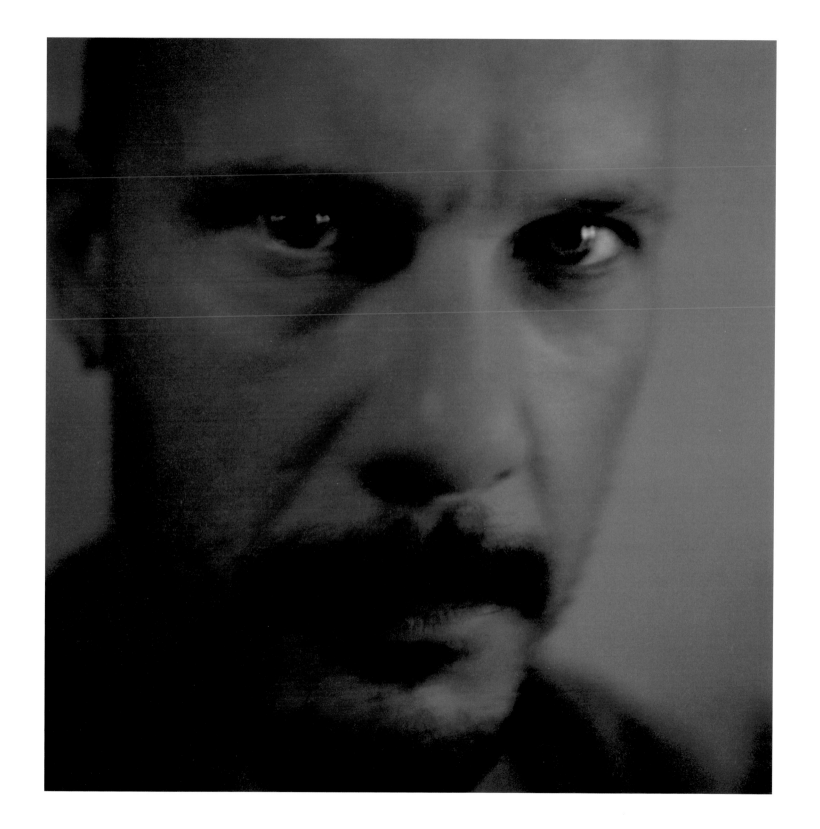

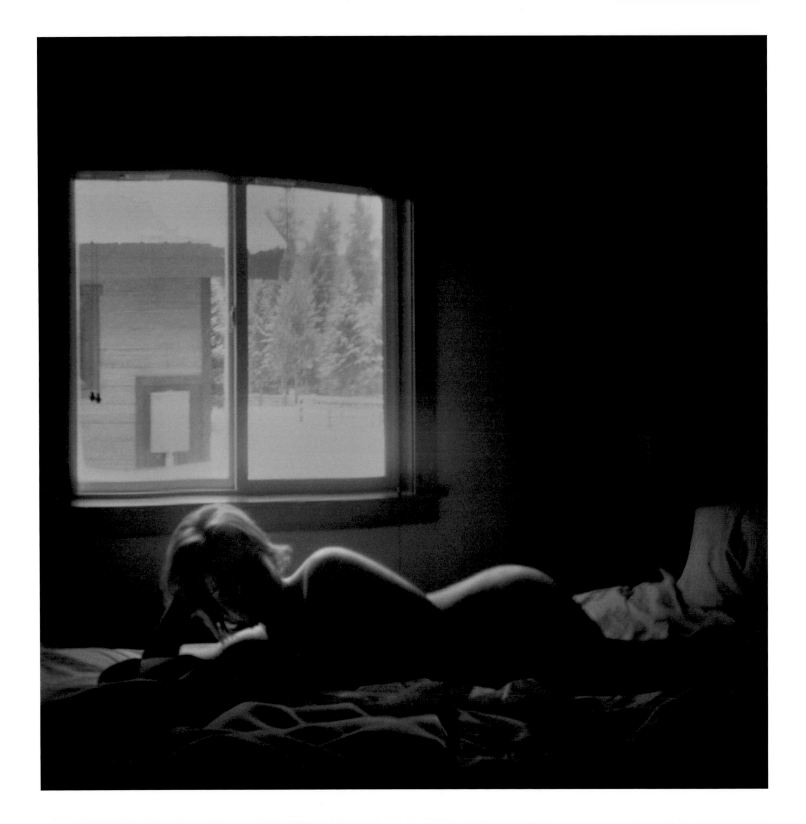

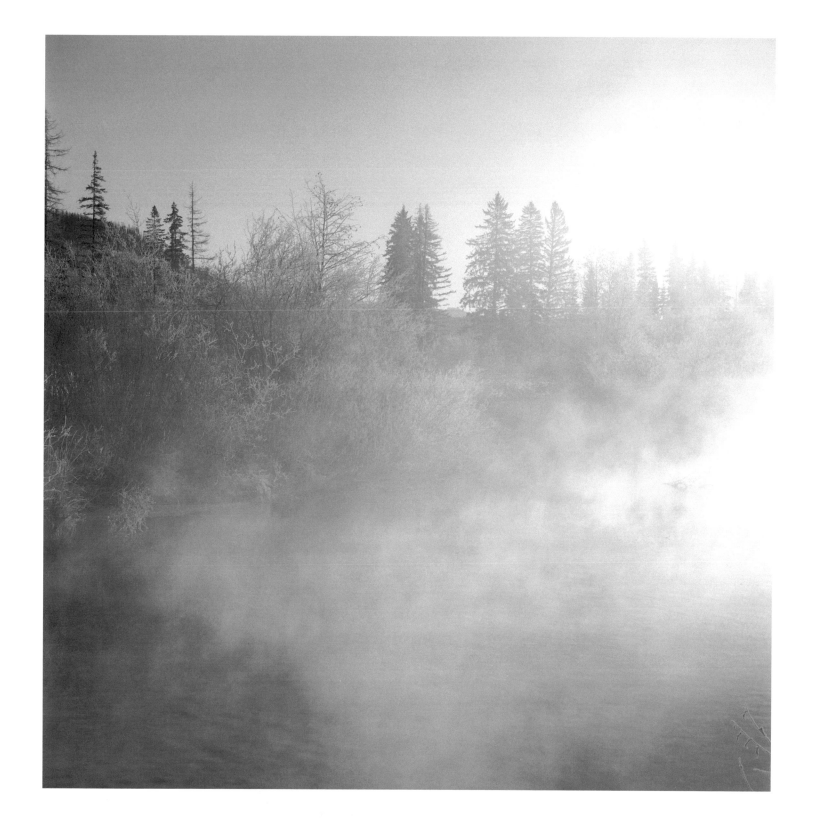

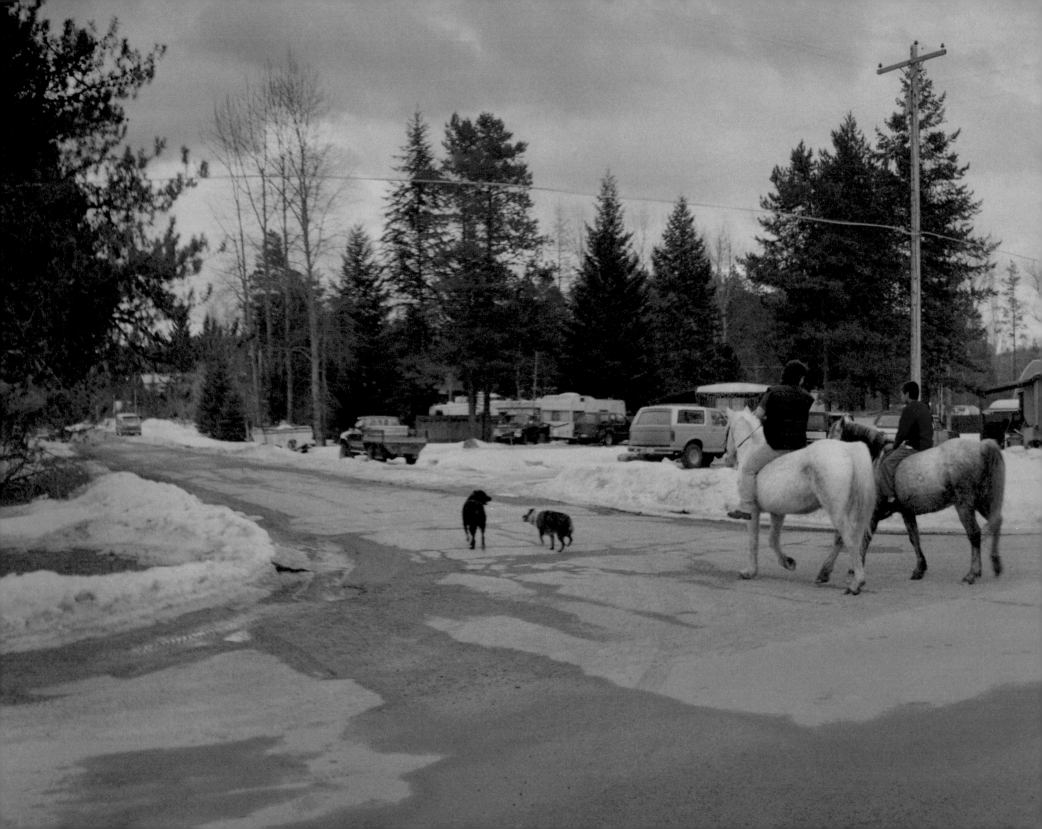

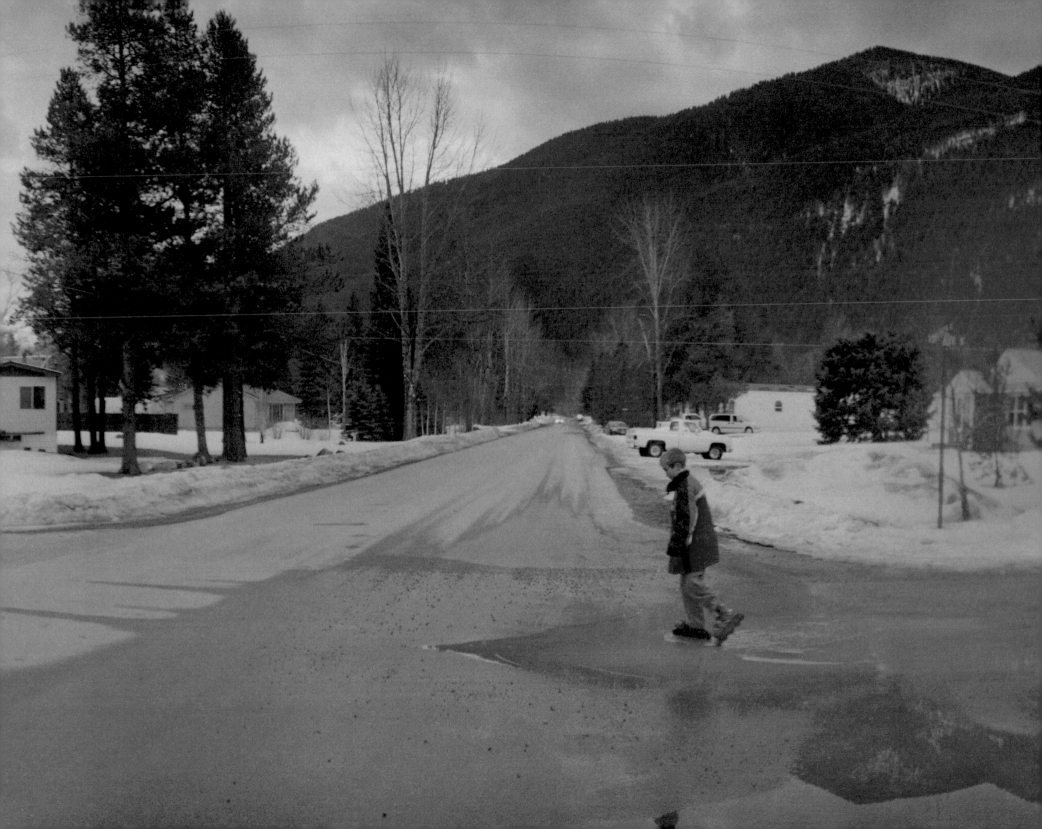

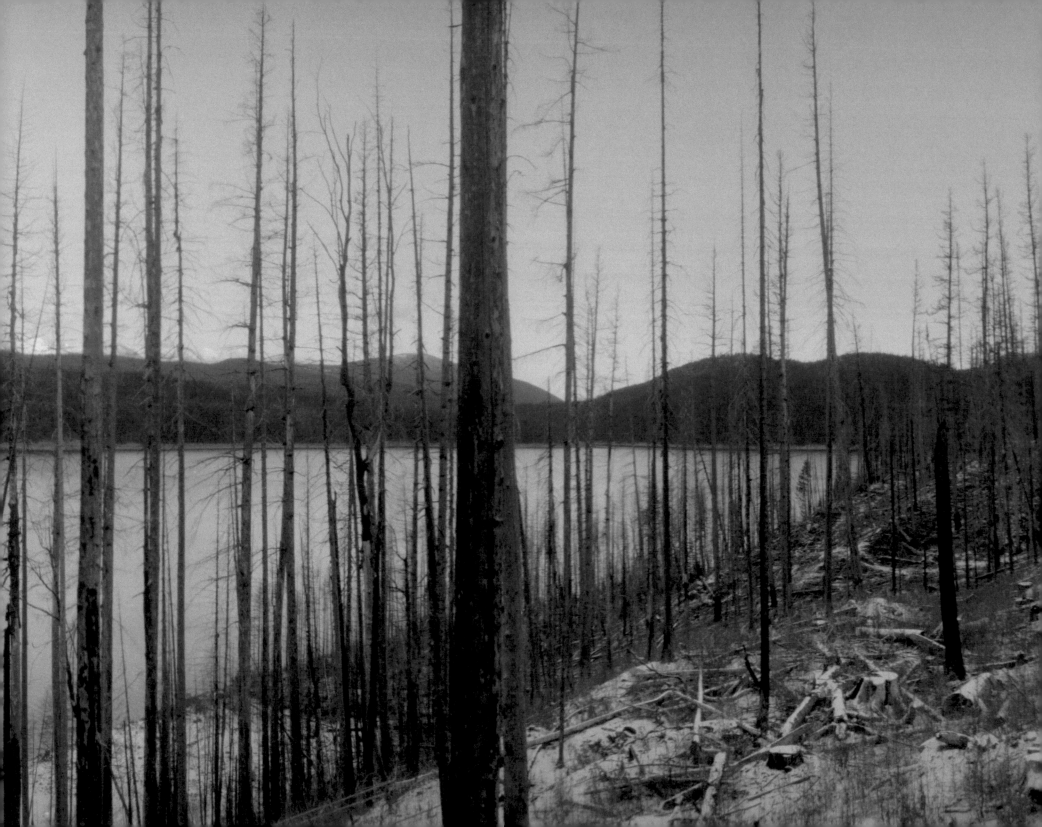

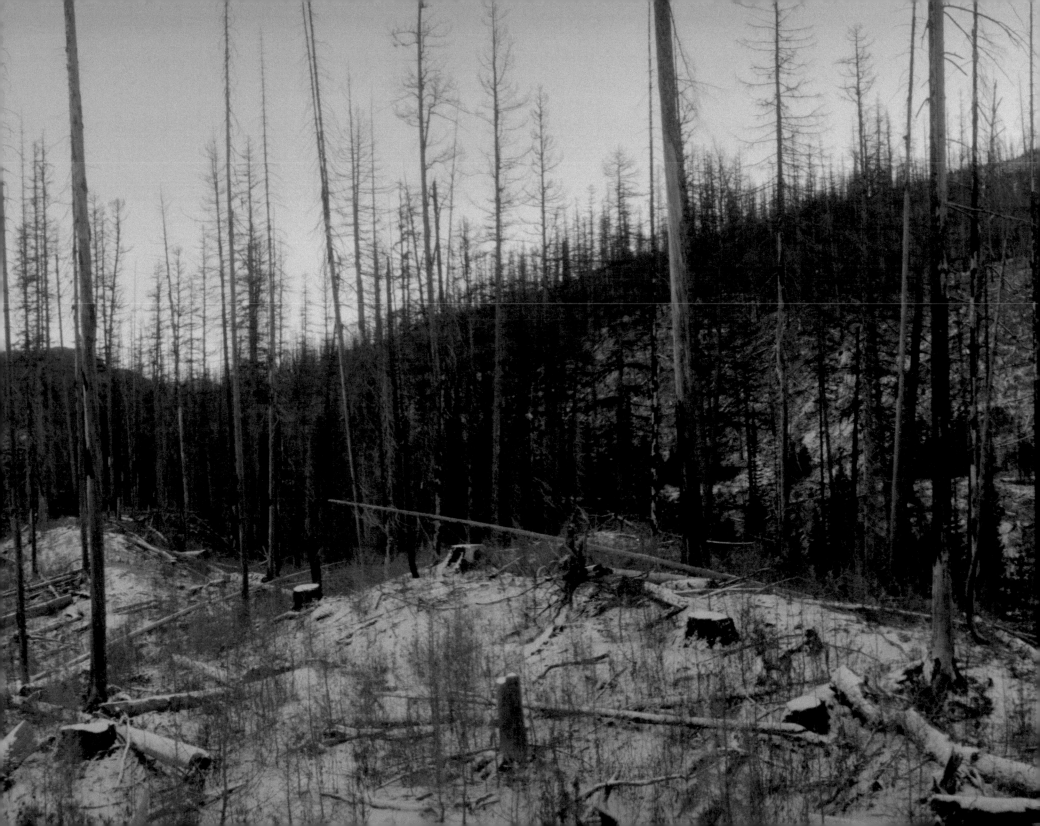

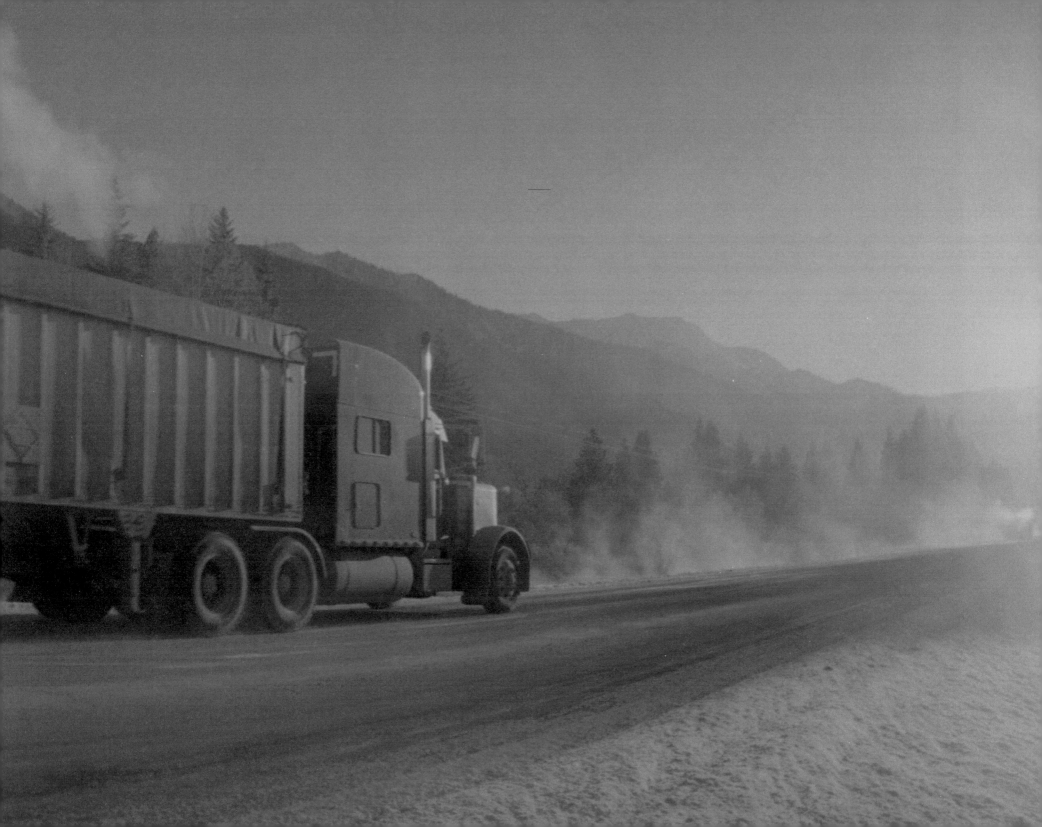

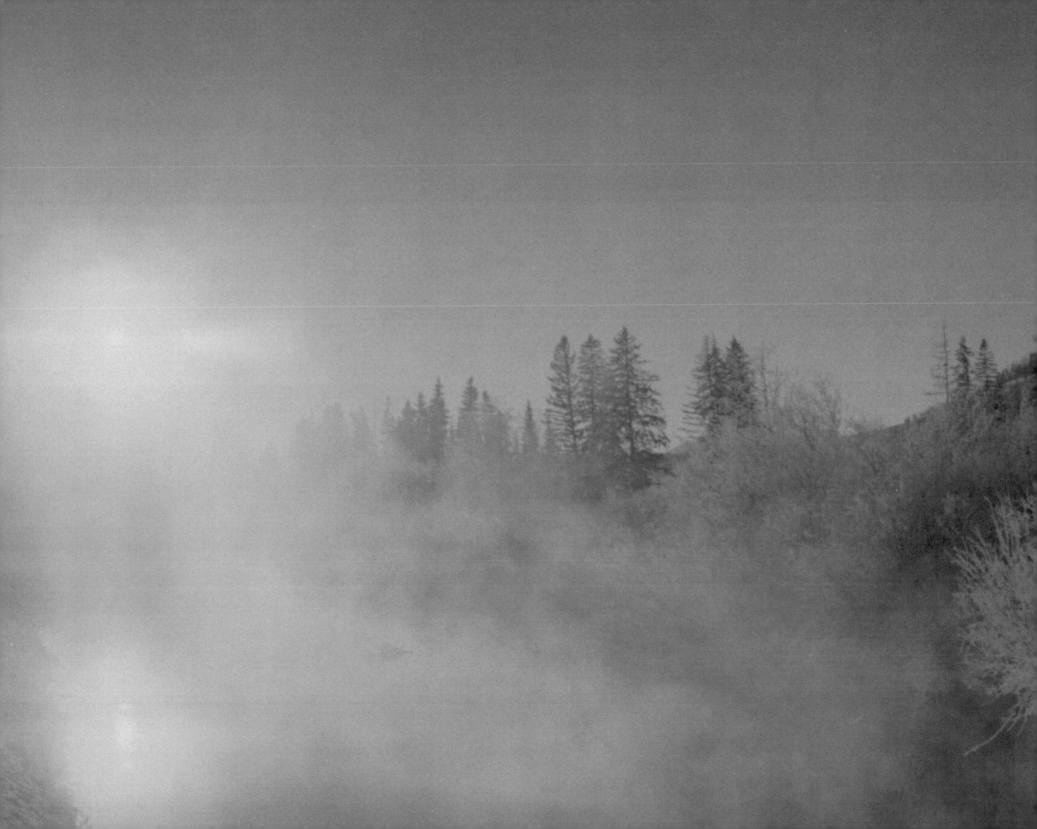

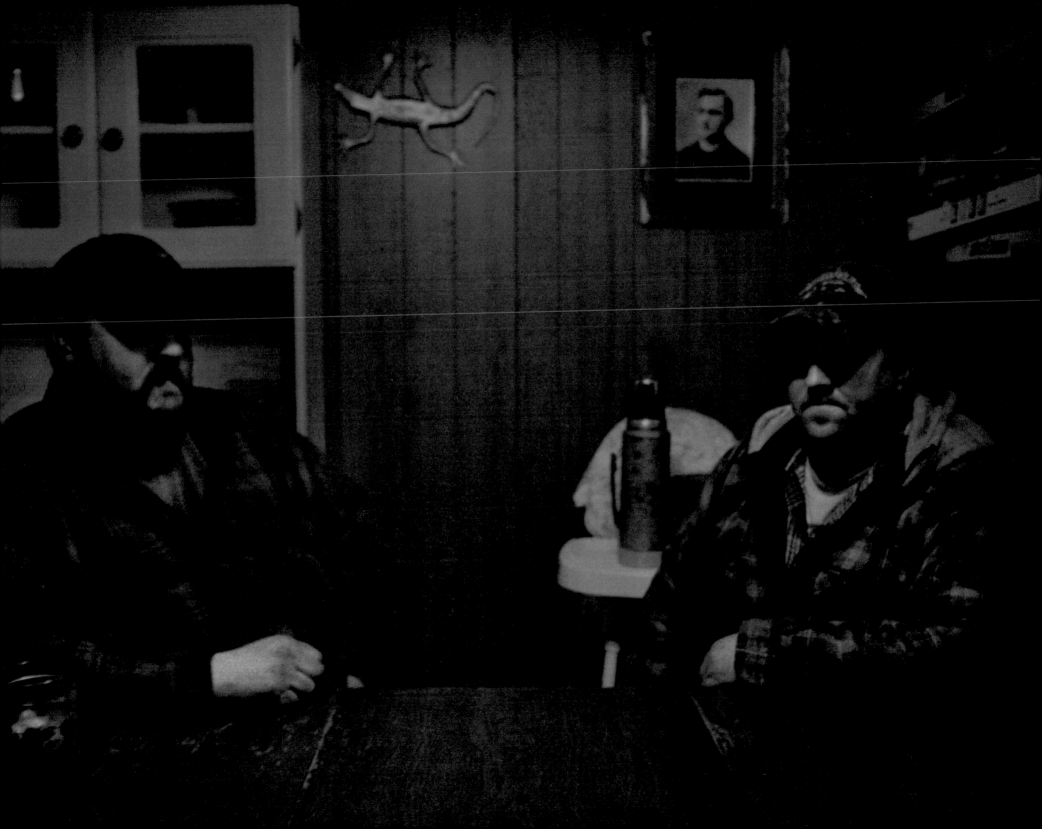

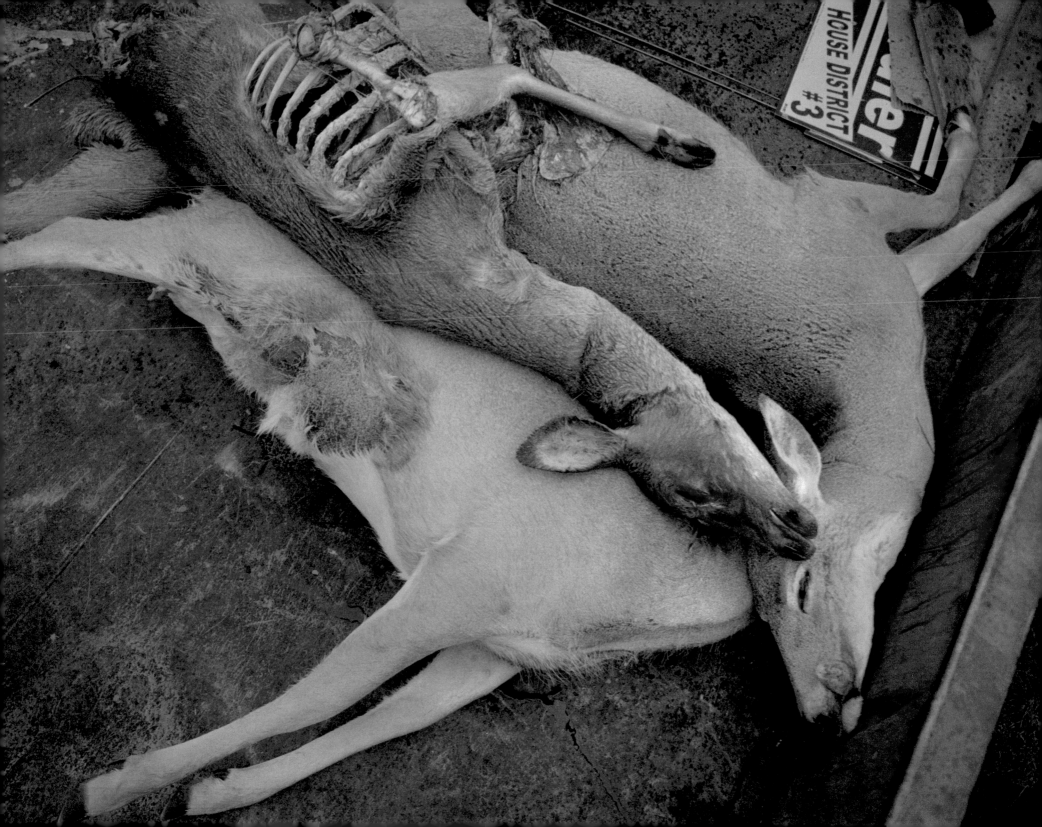

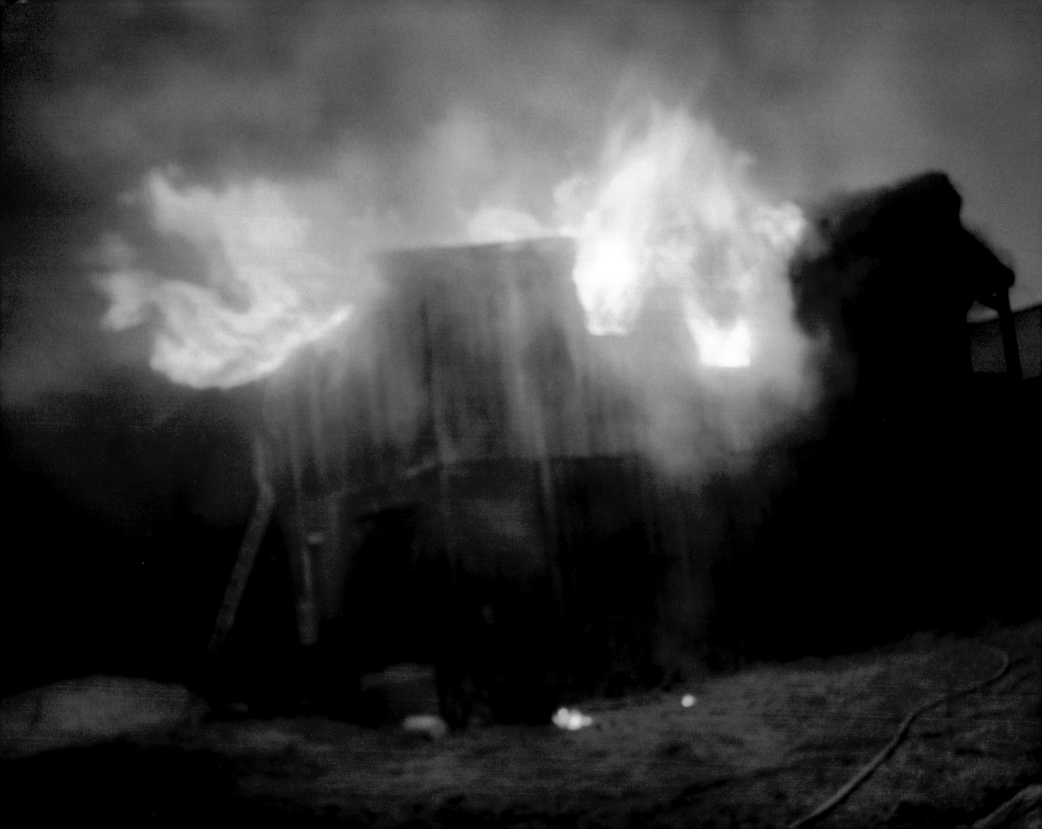

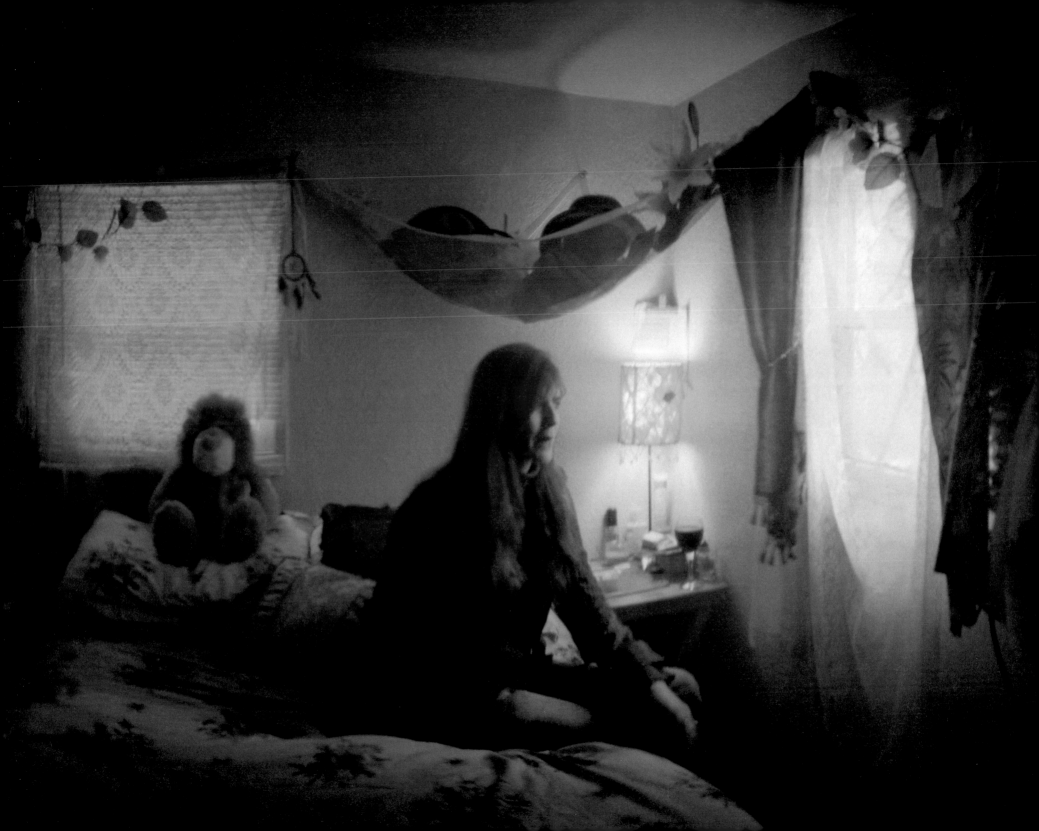

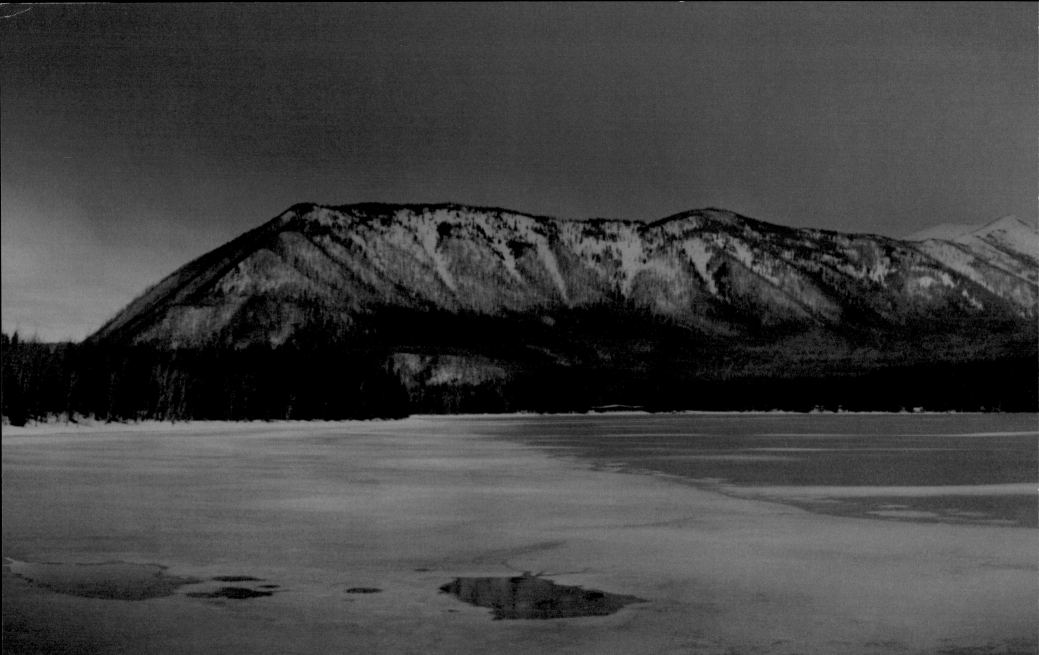

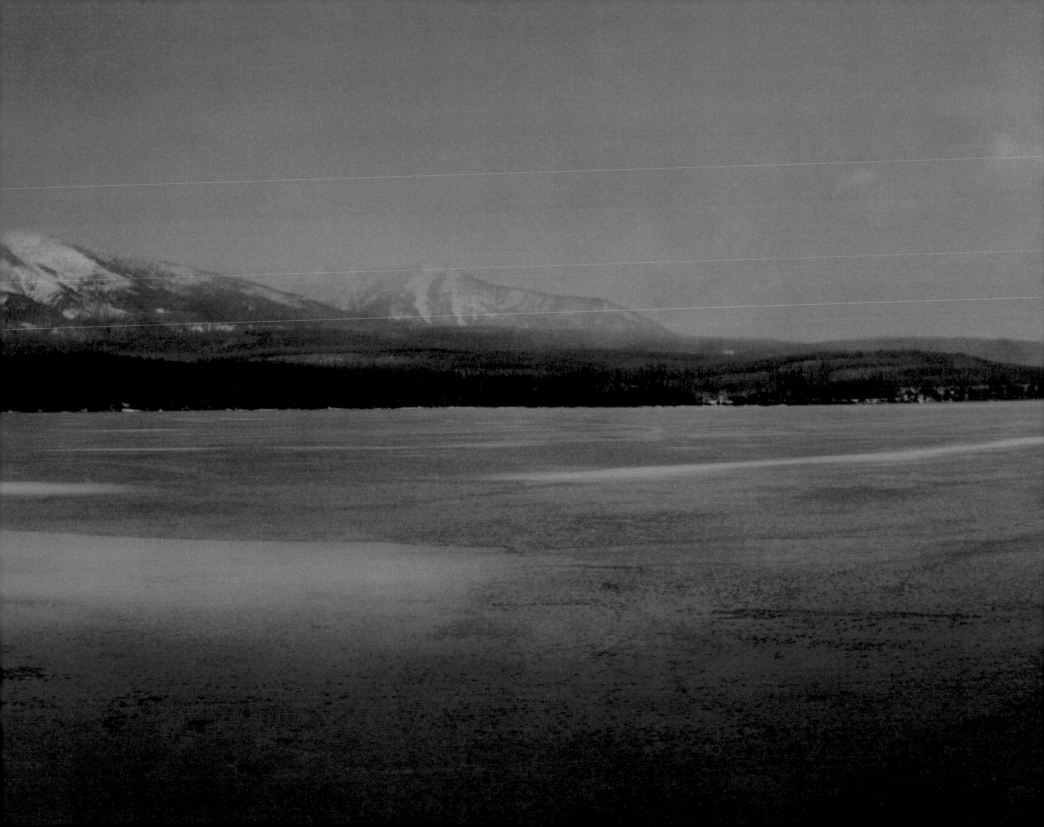

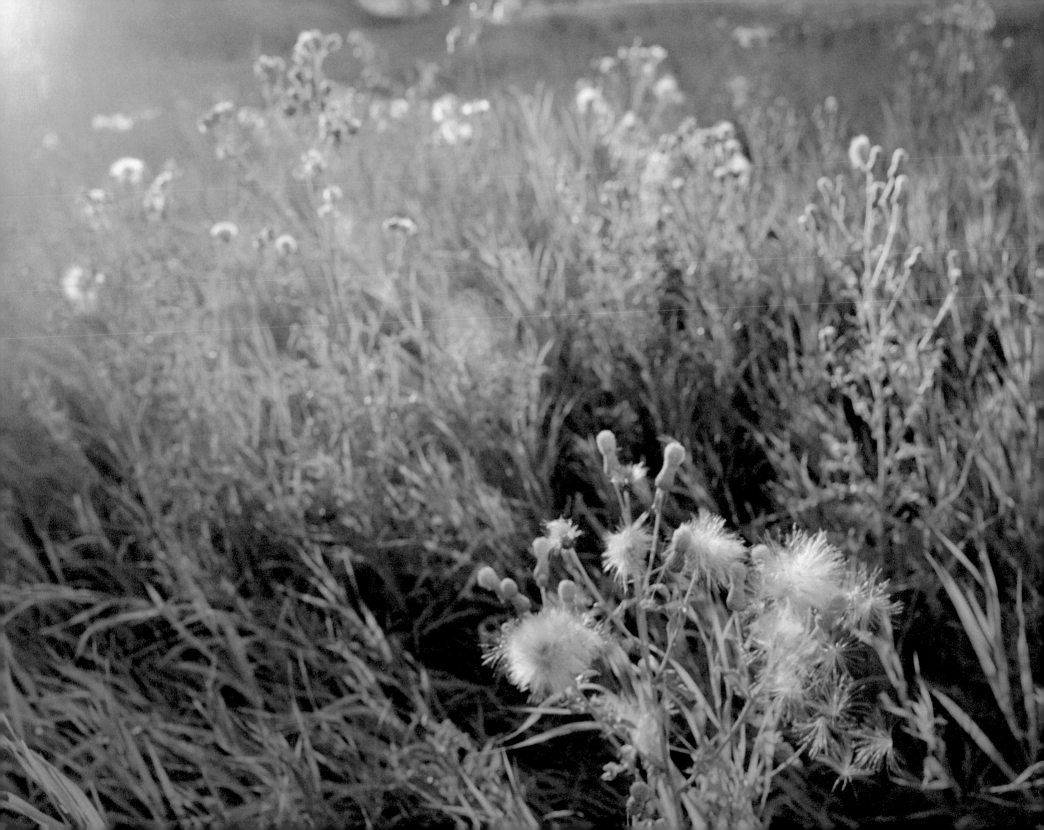

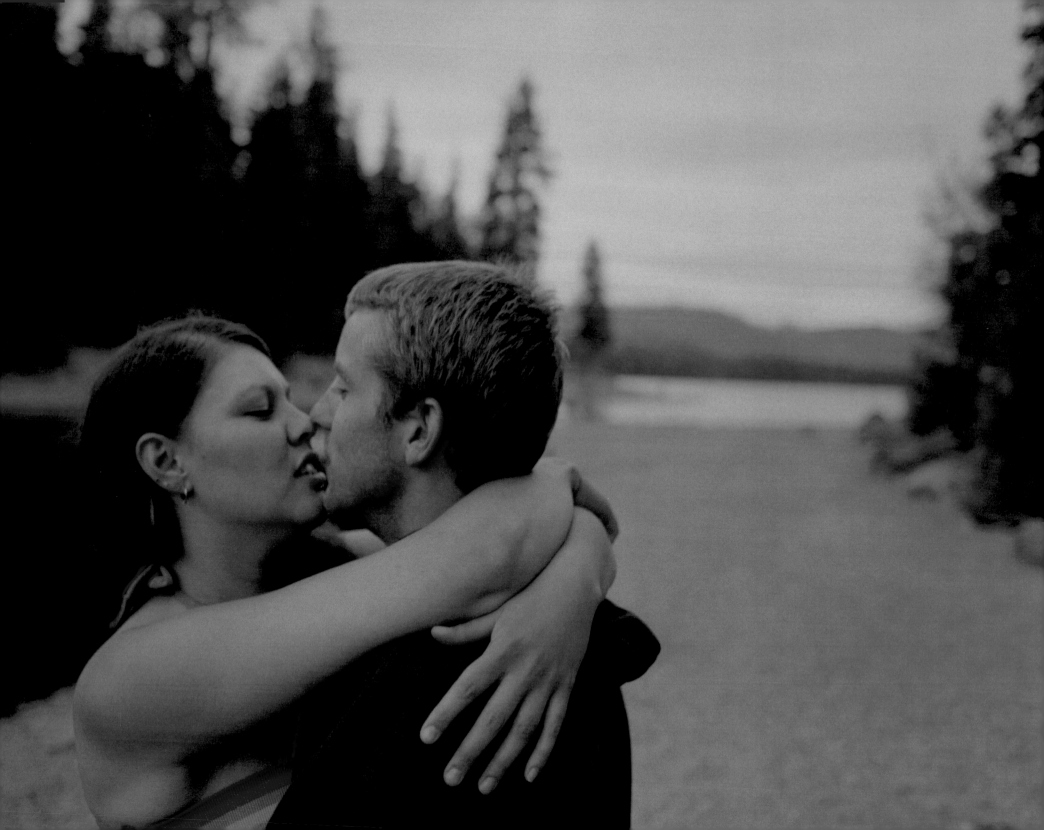

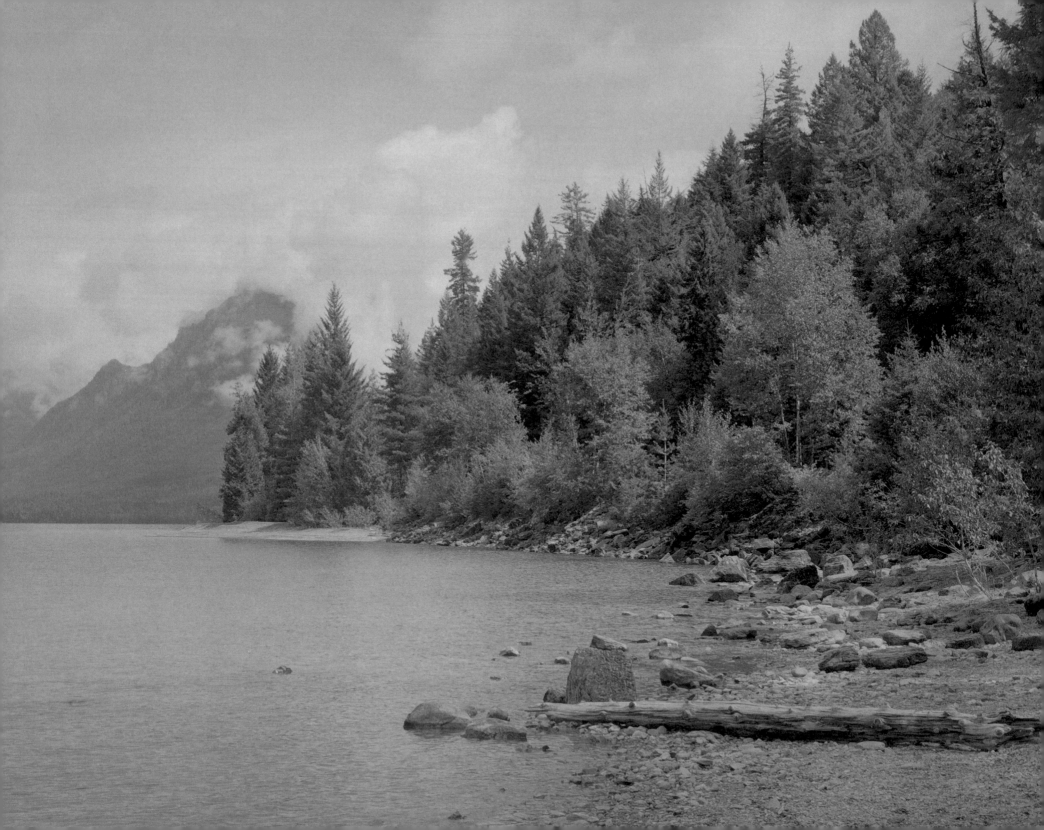

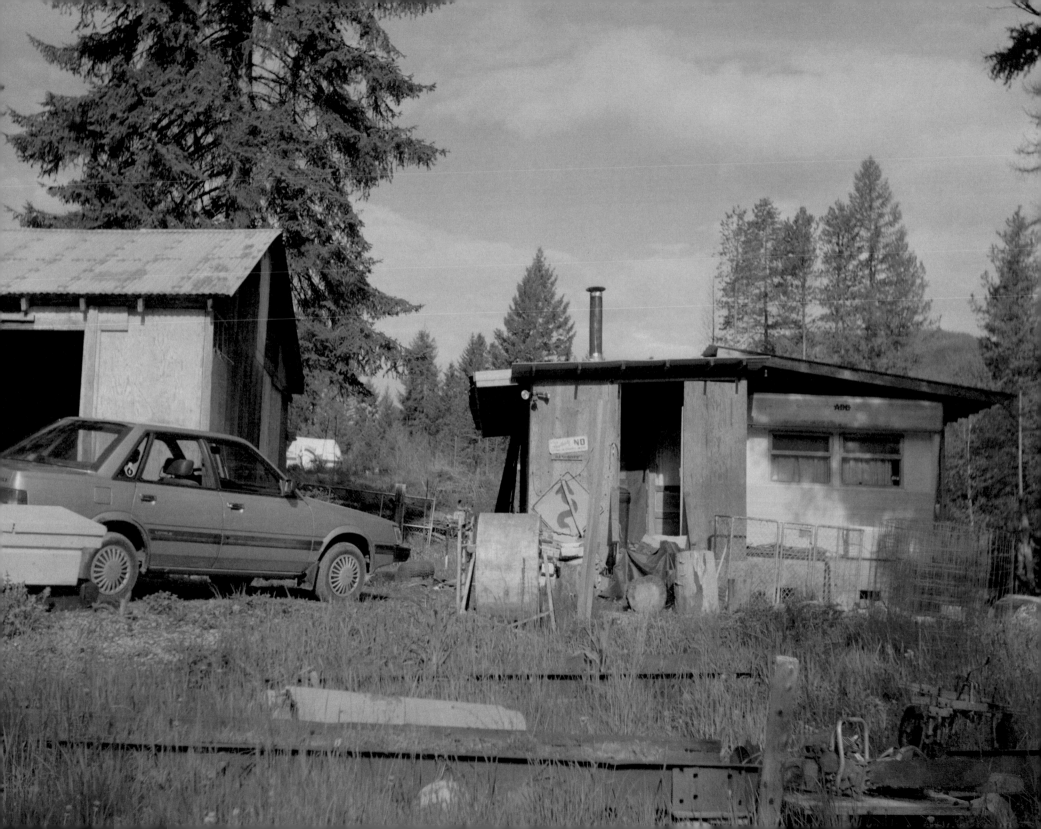

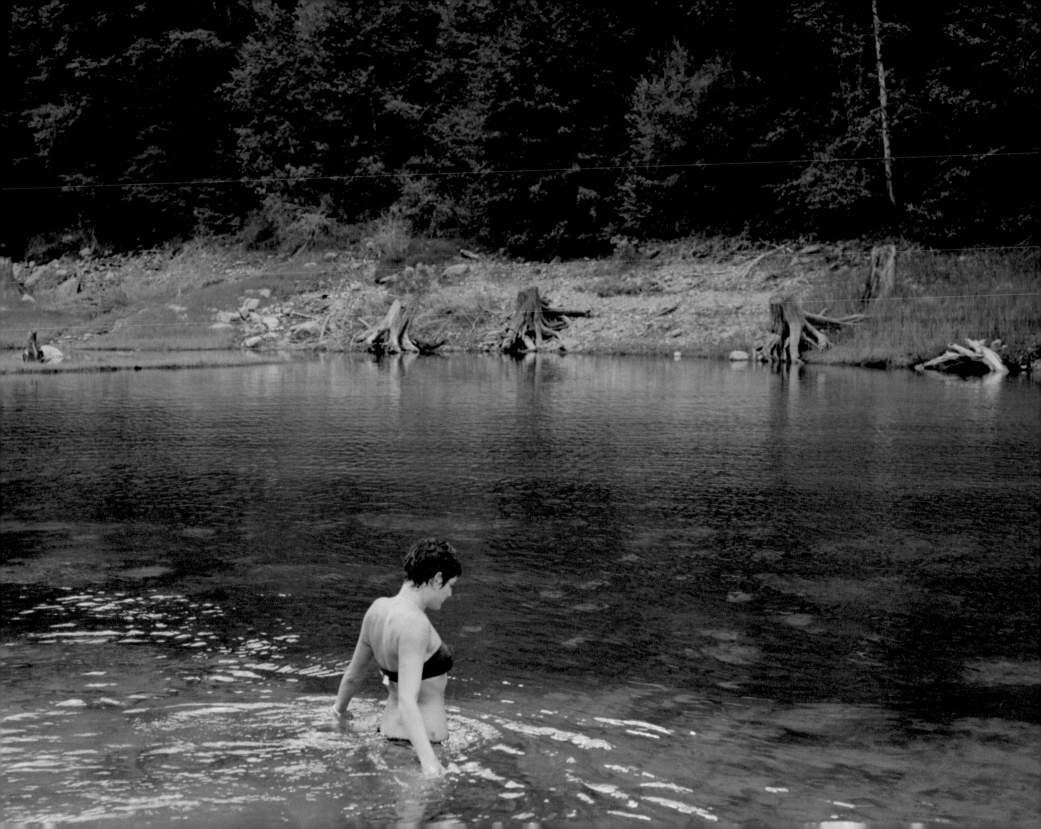

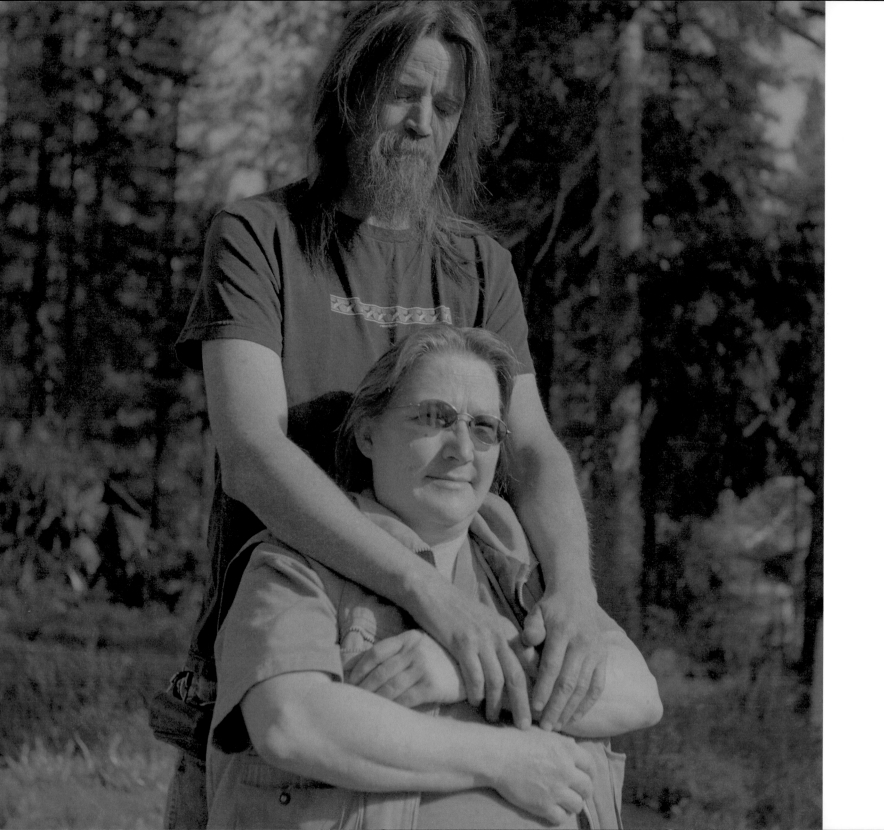

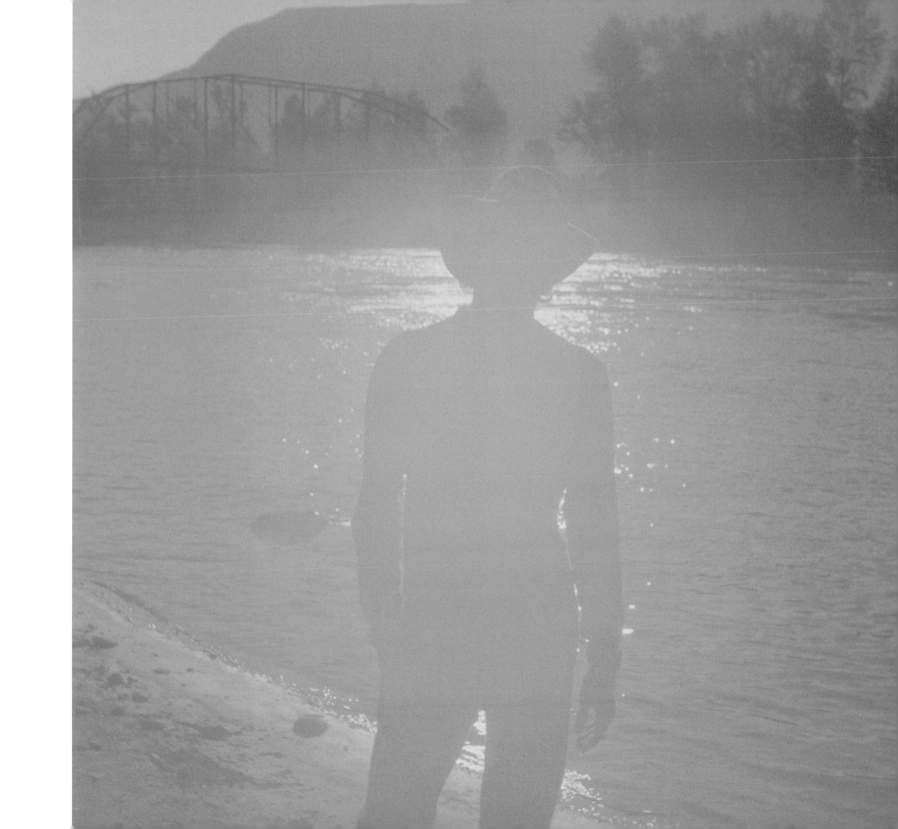

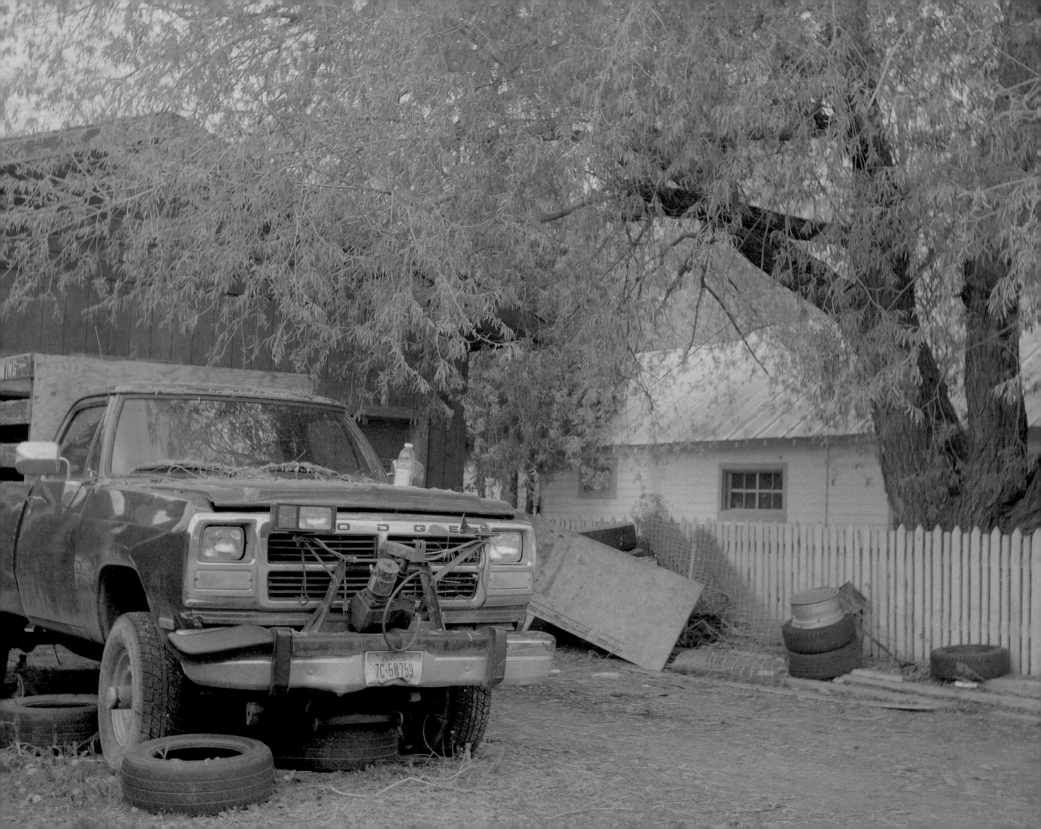

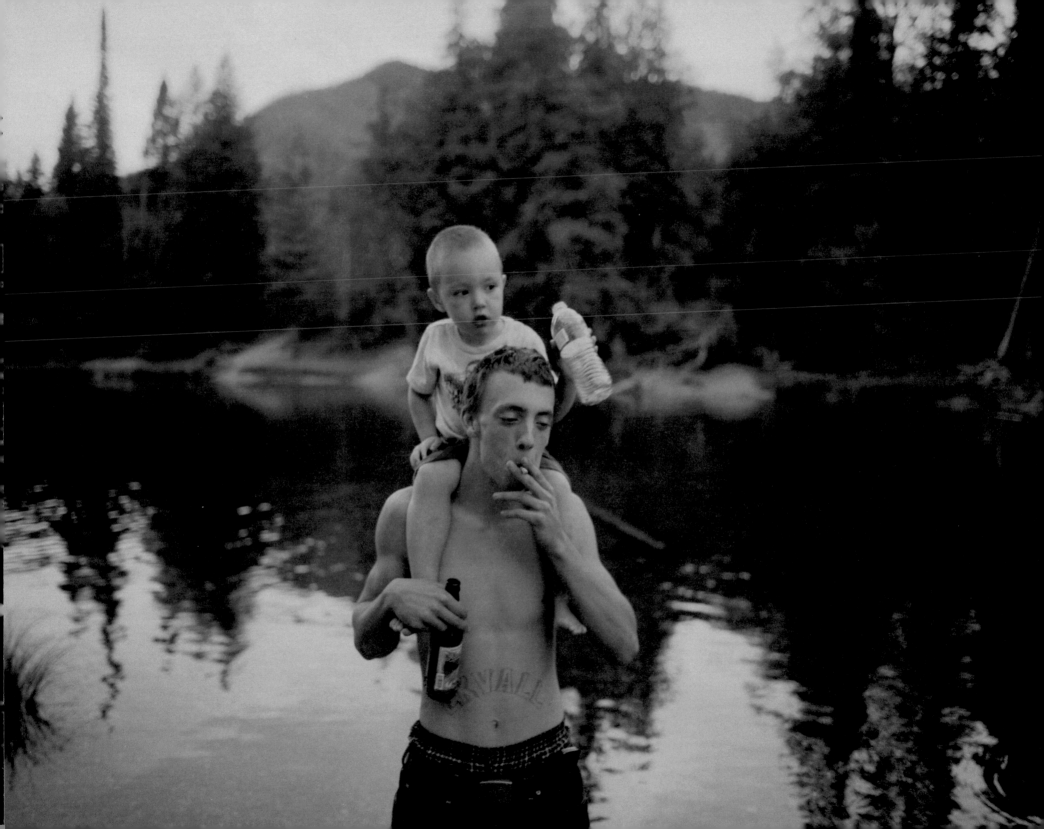

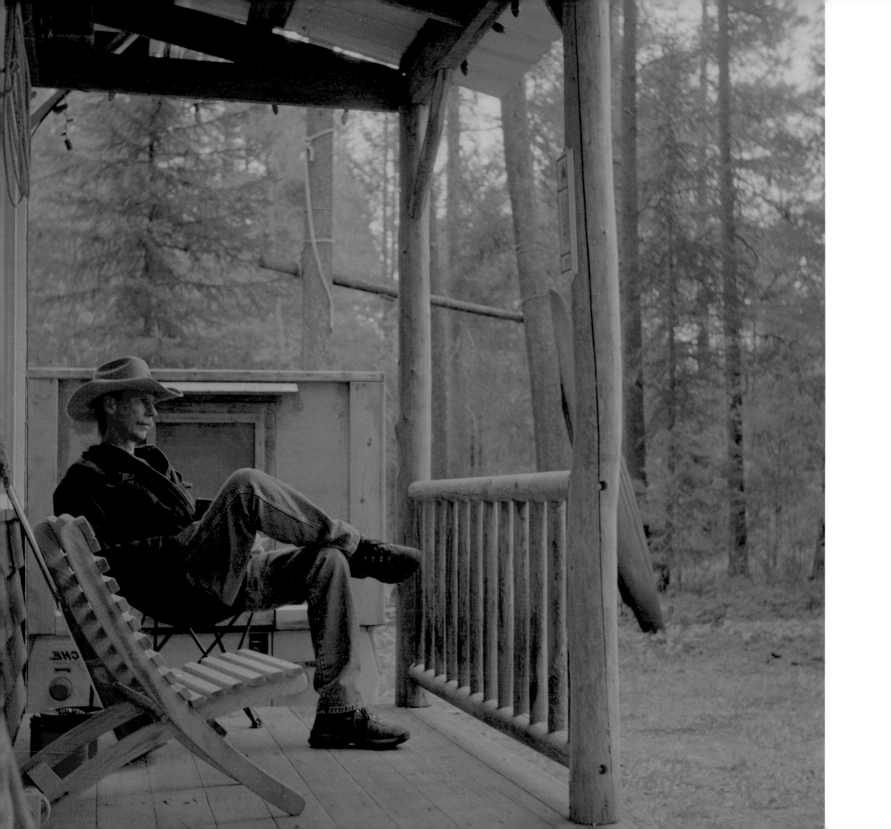

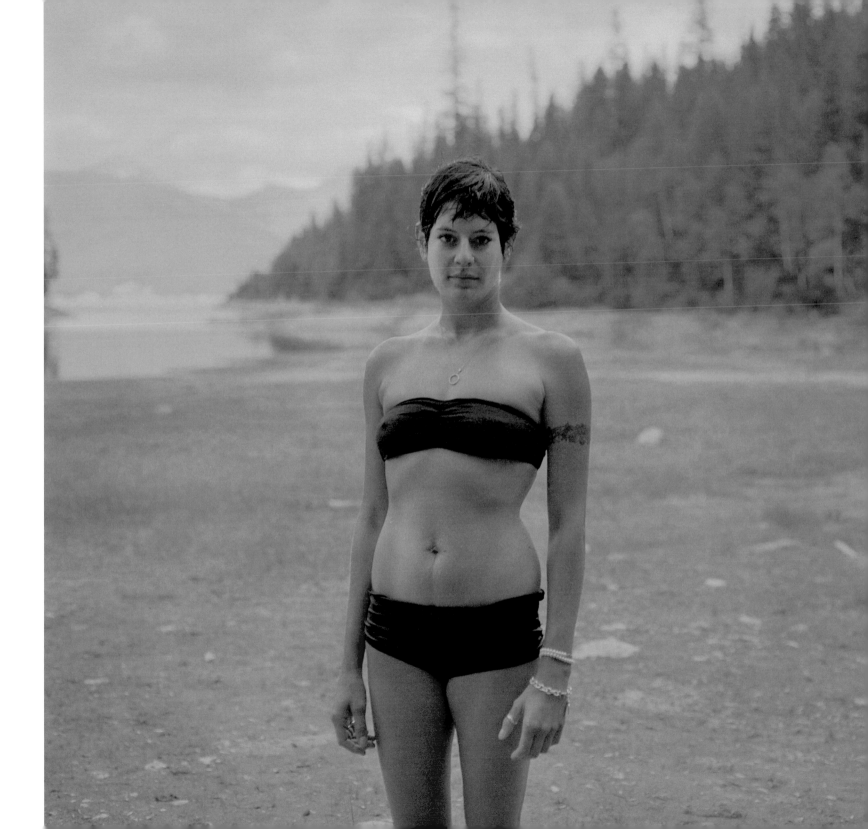

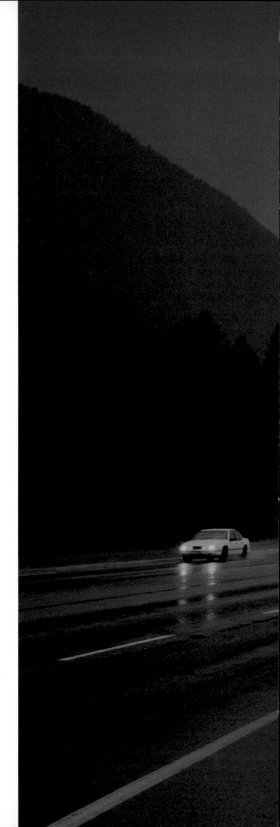

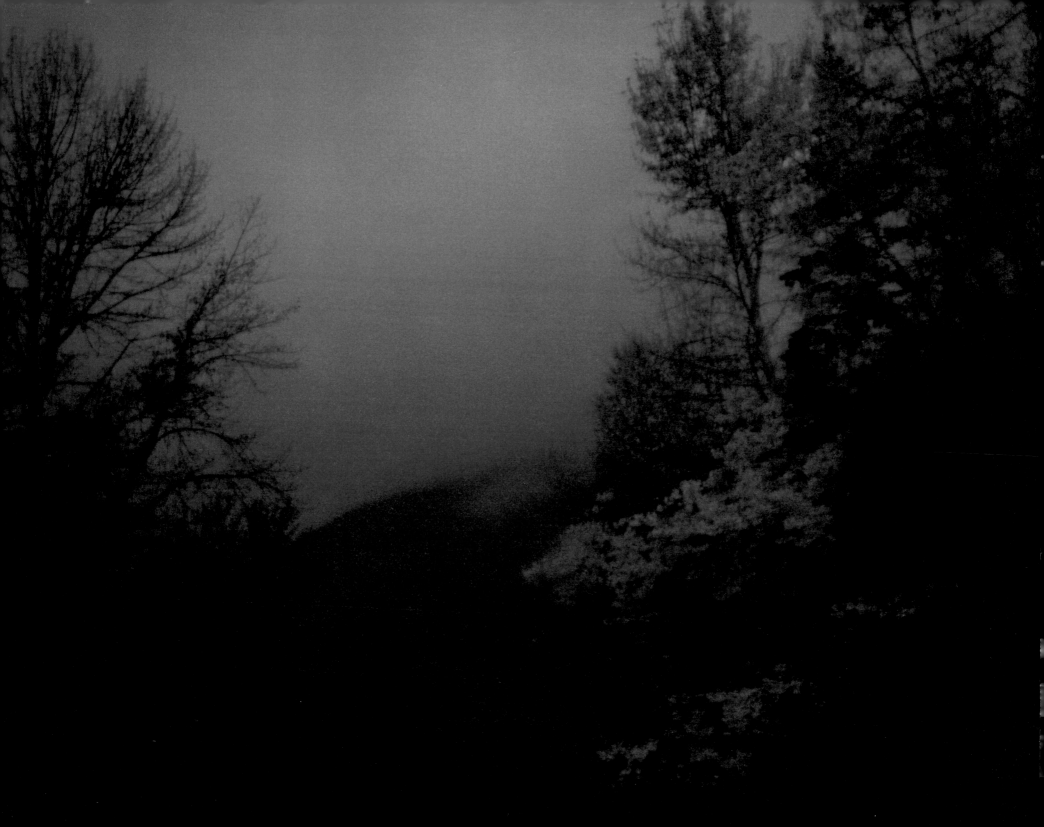

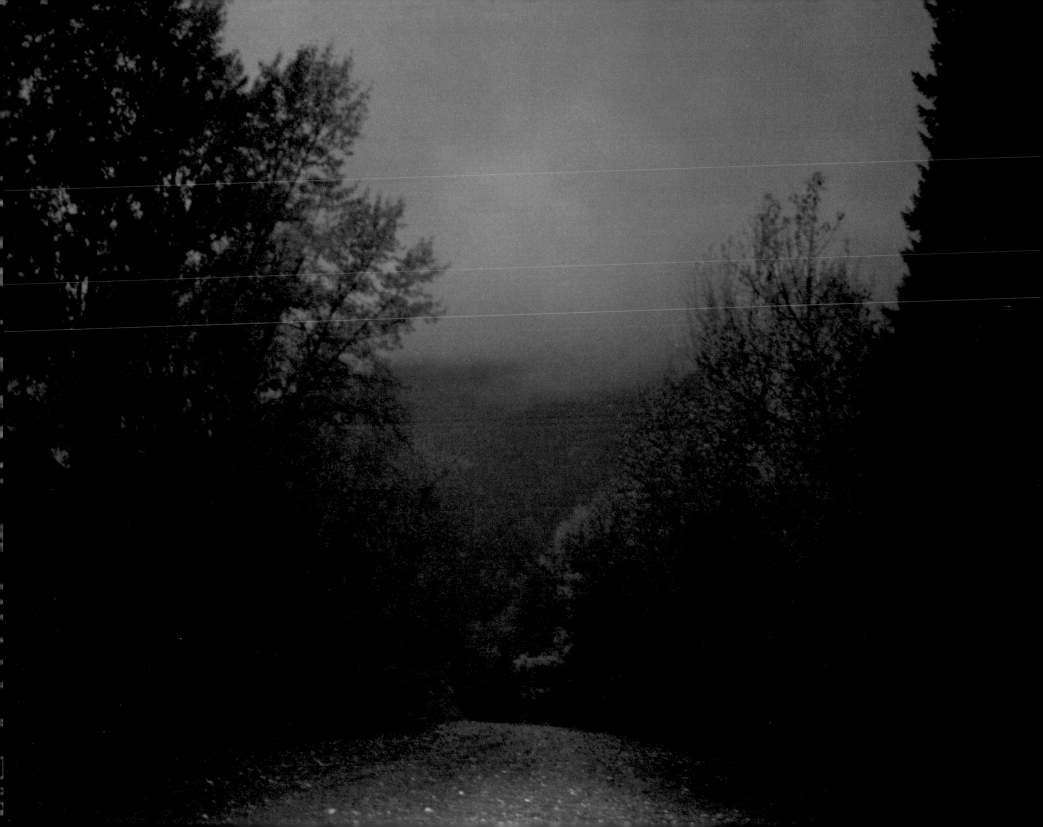

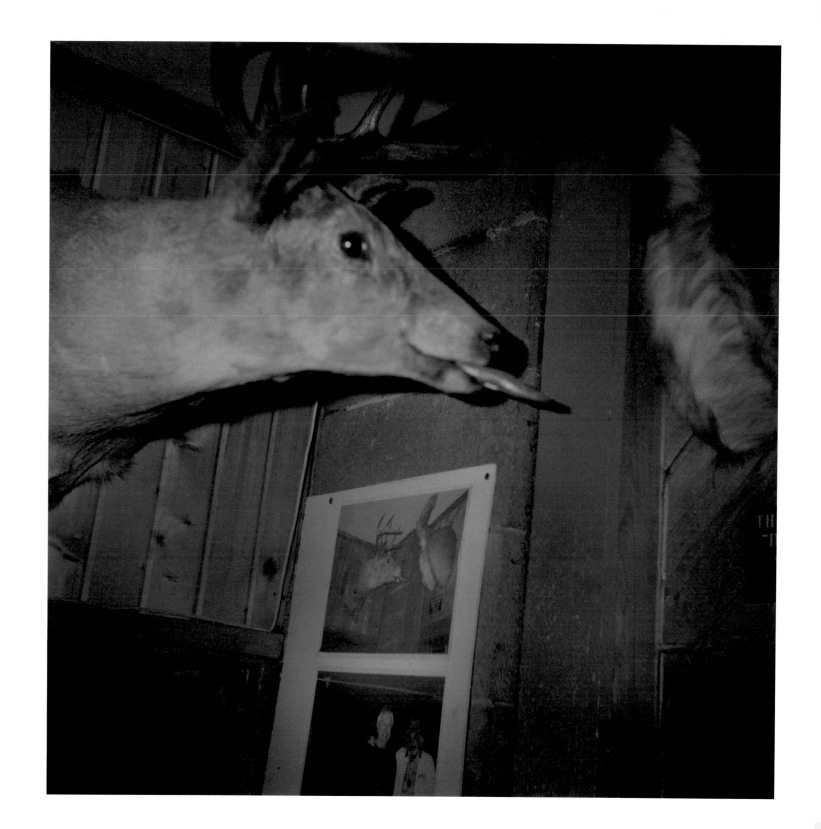

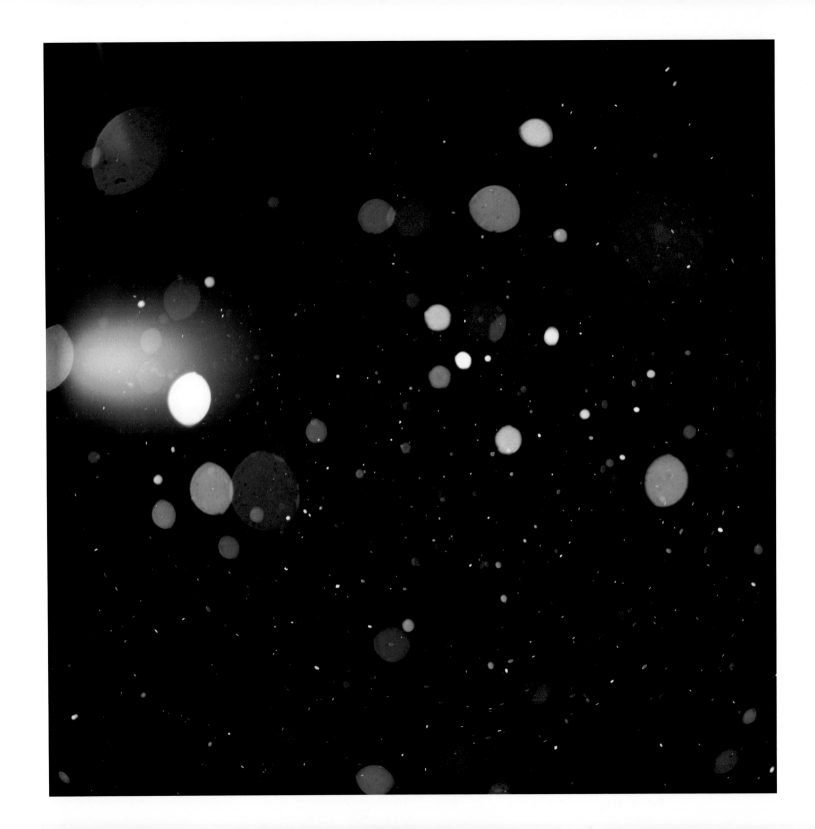

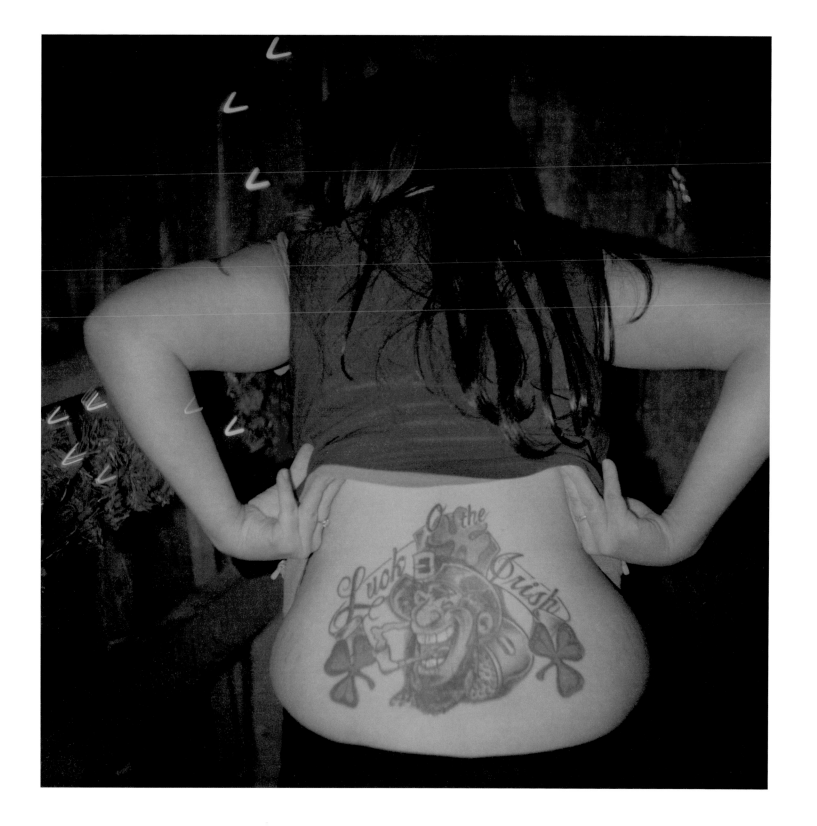

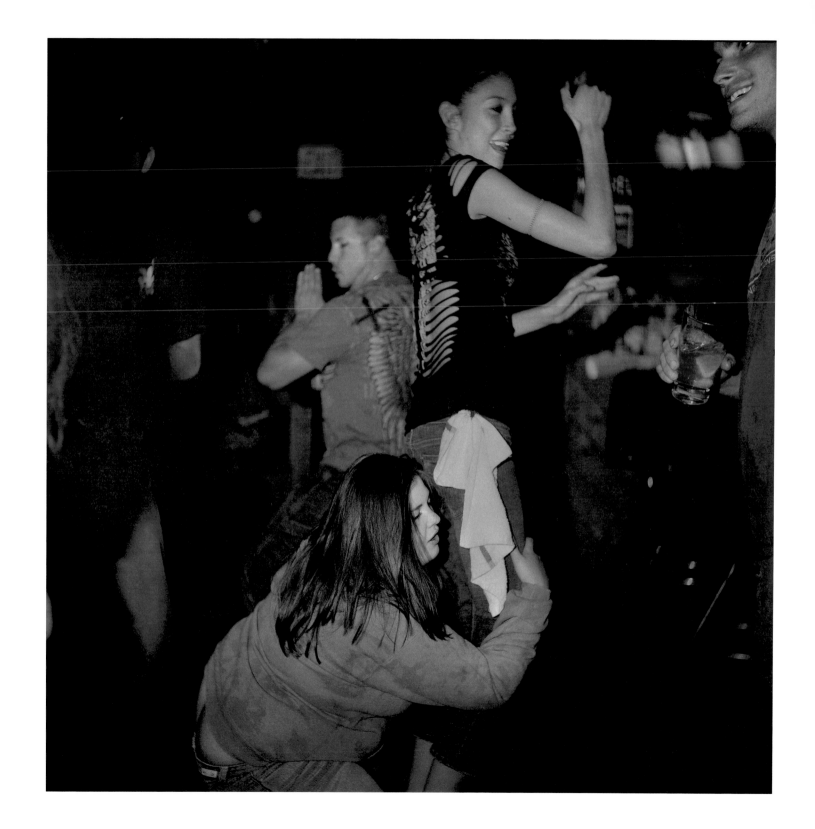

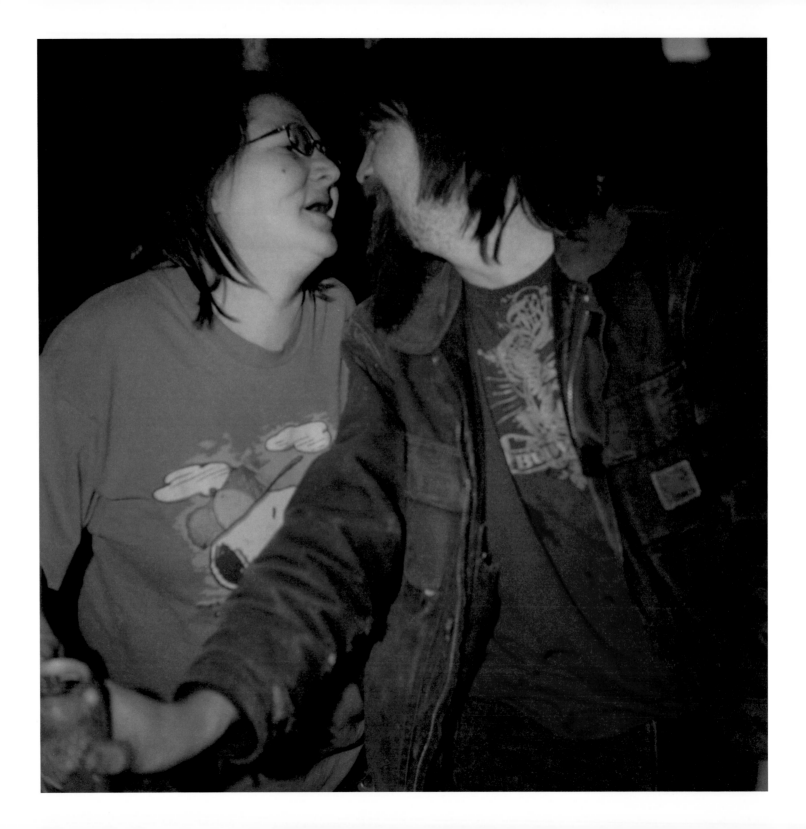

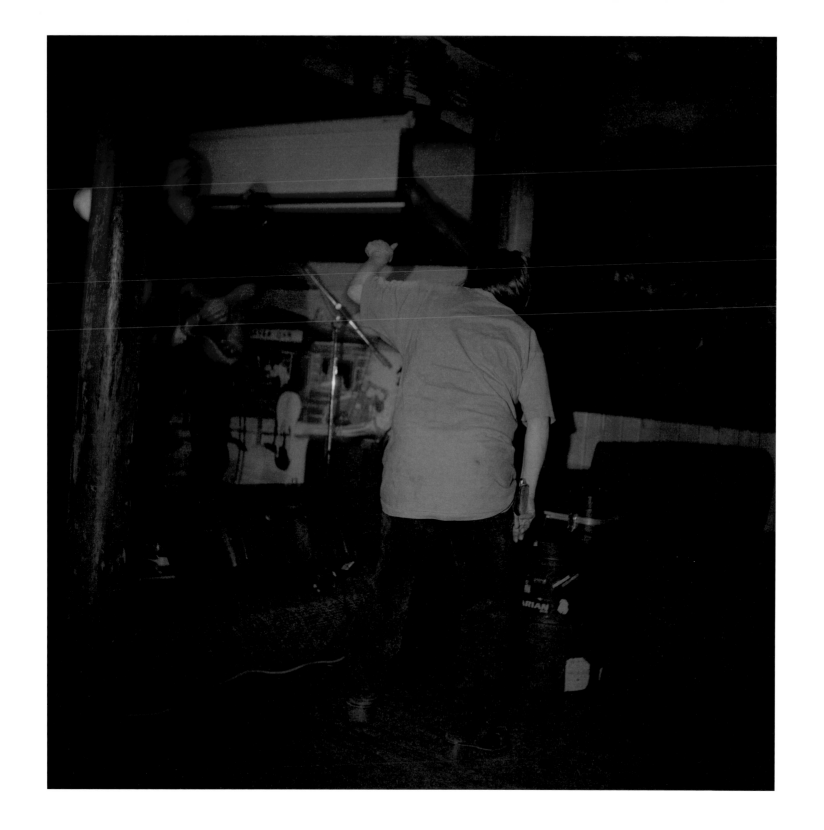

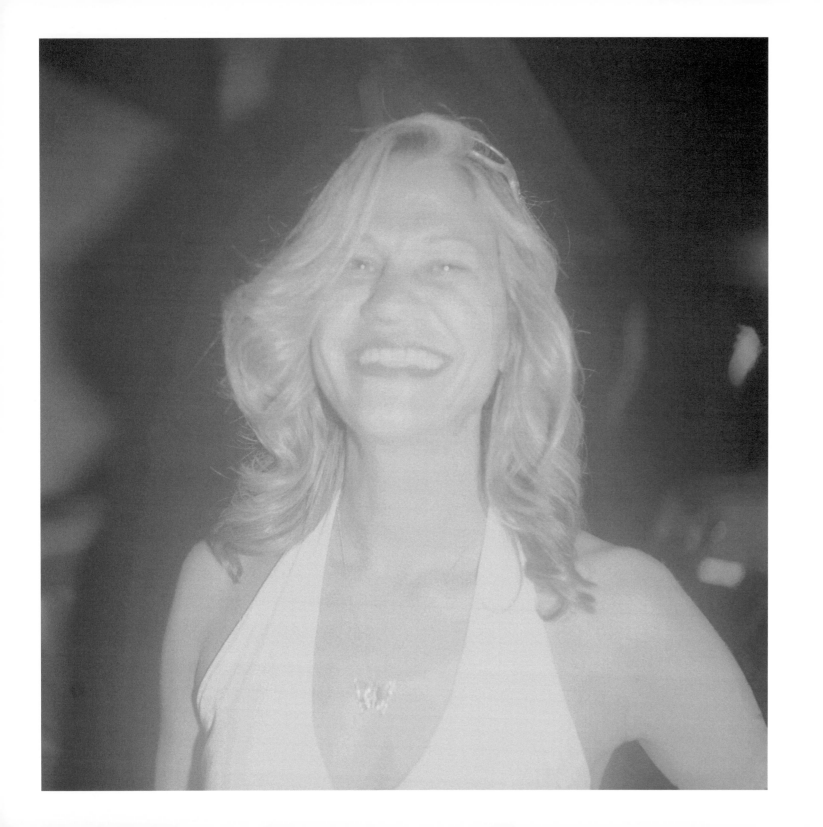

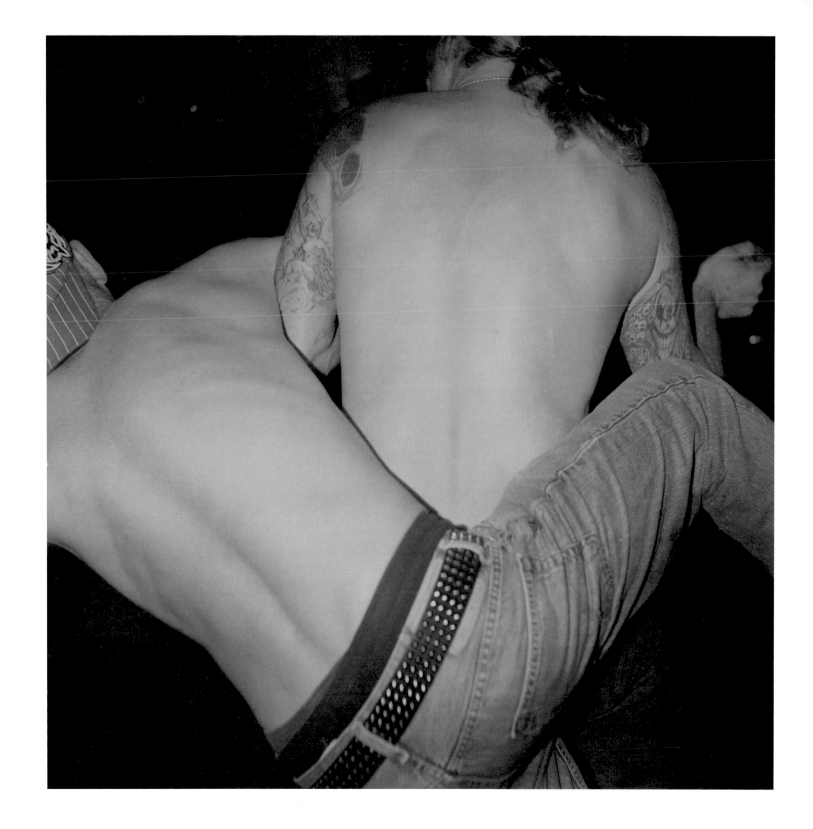

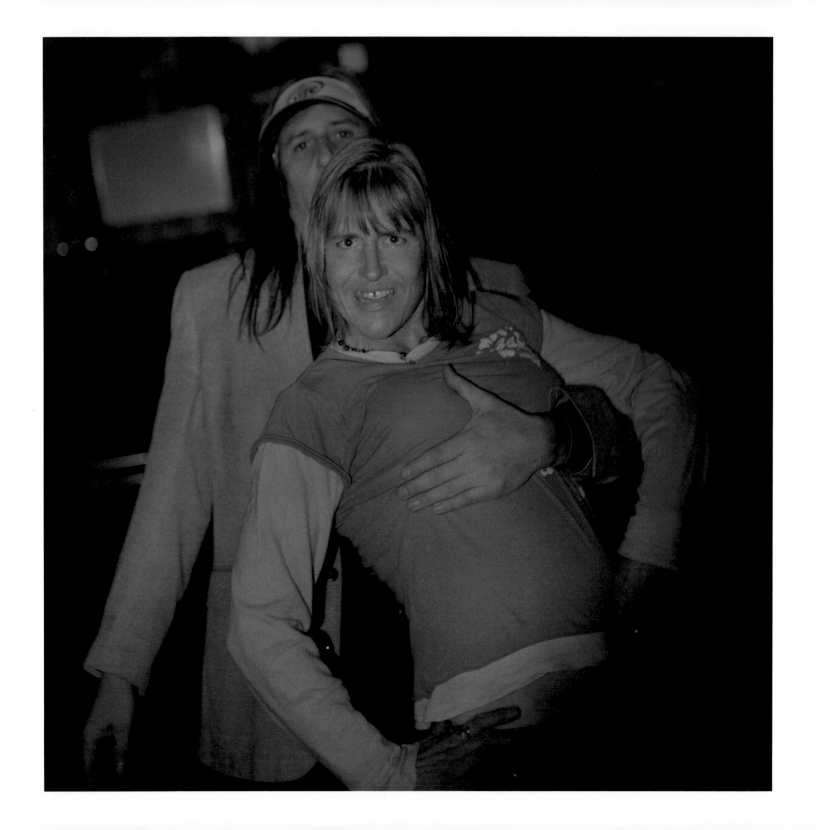

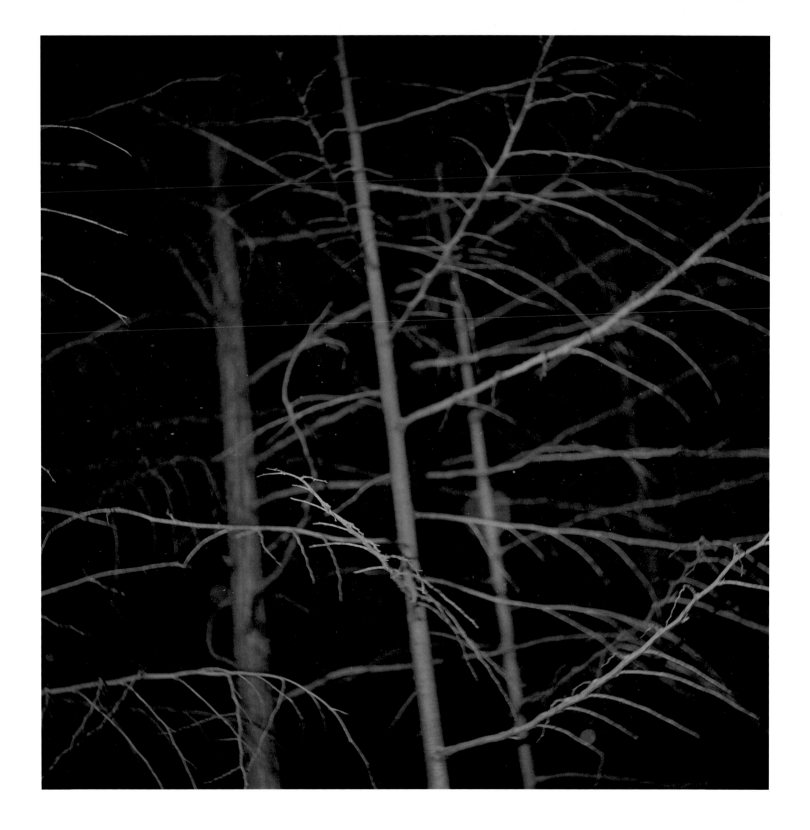

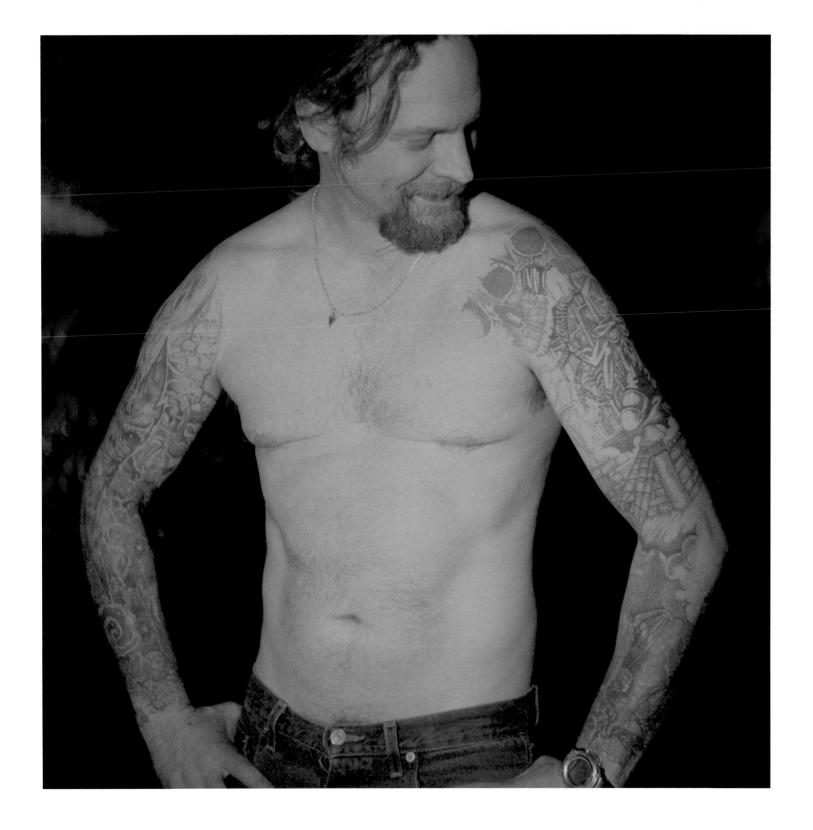

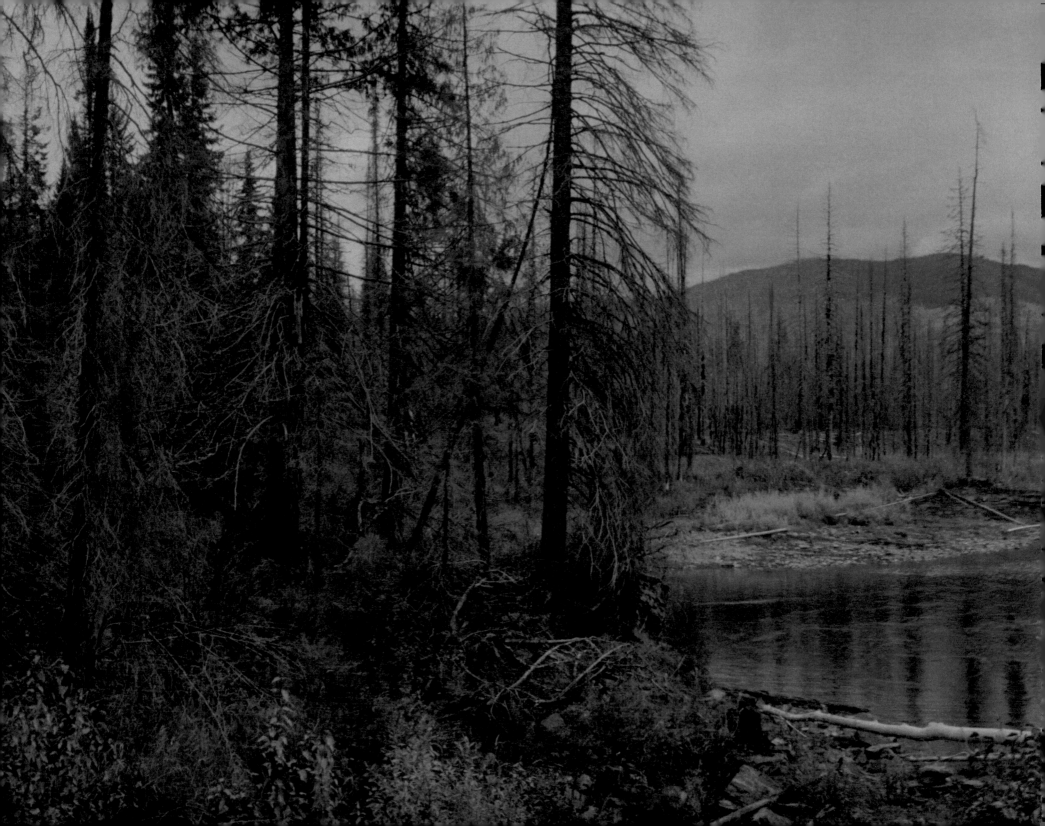

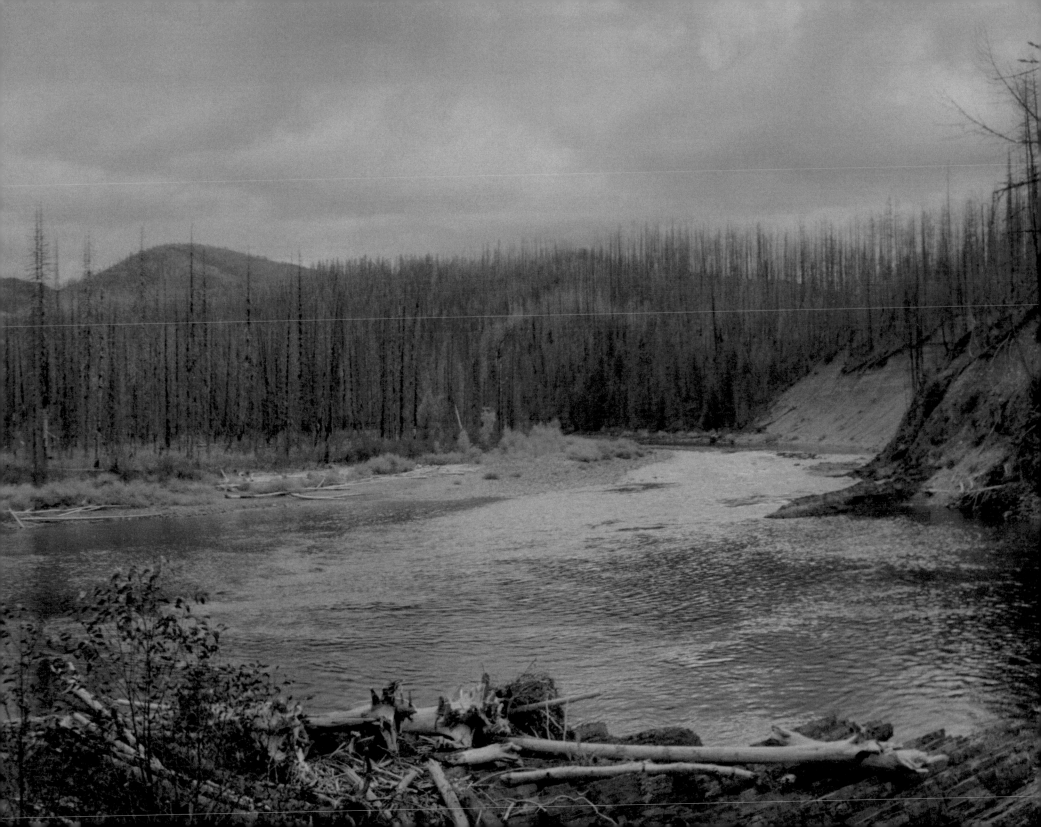

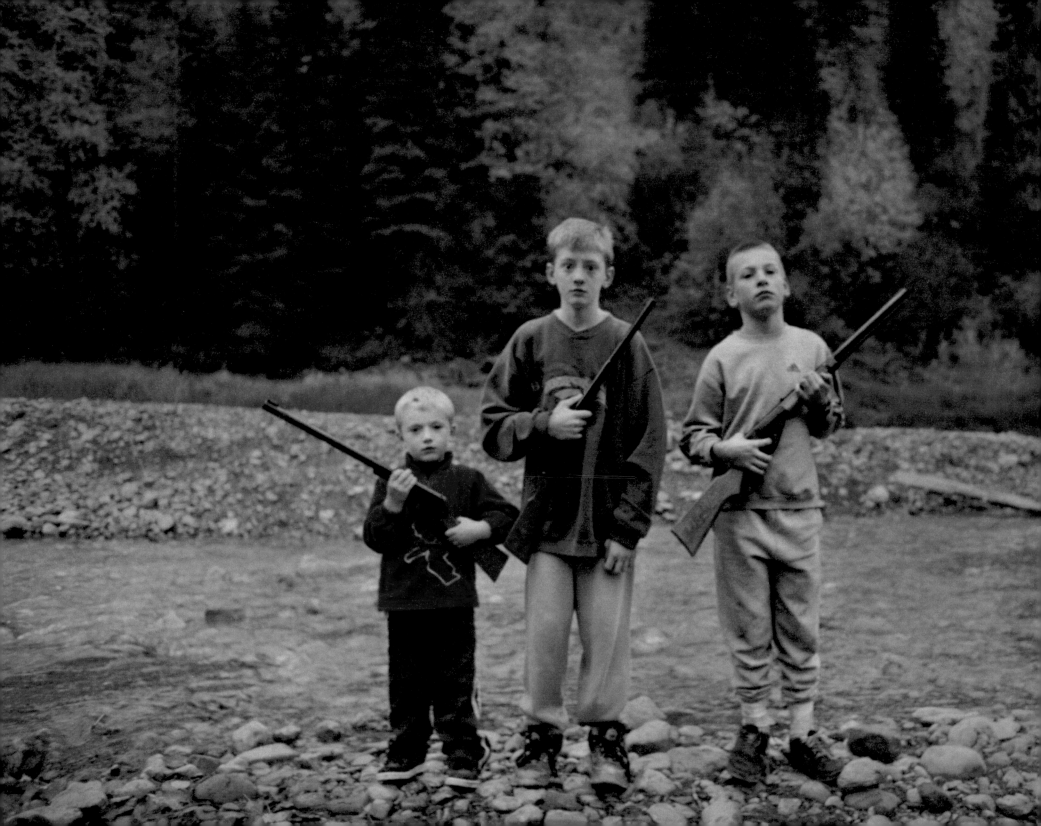

Stonefly
LOUNGE

LIVE MUSIC • EAT

THE GOOD BEER

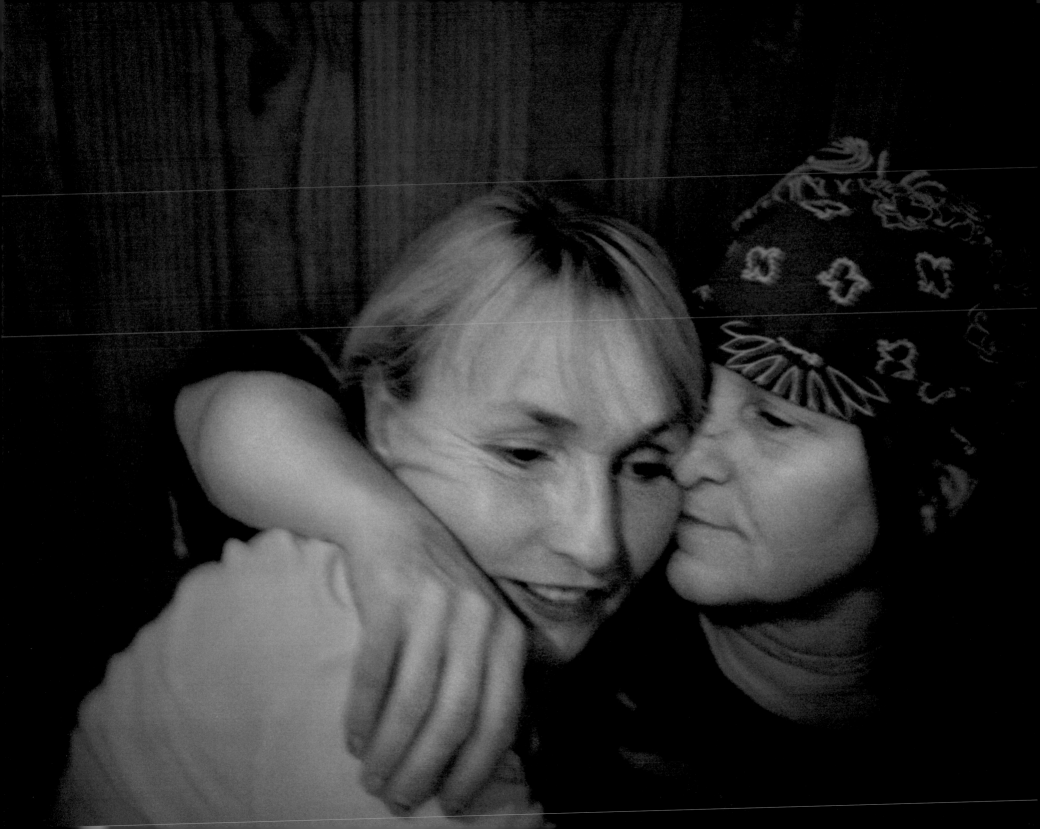

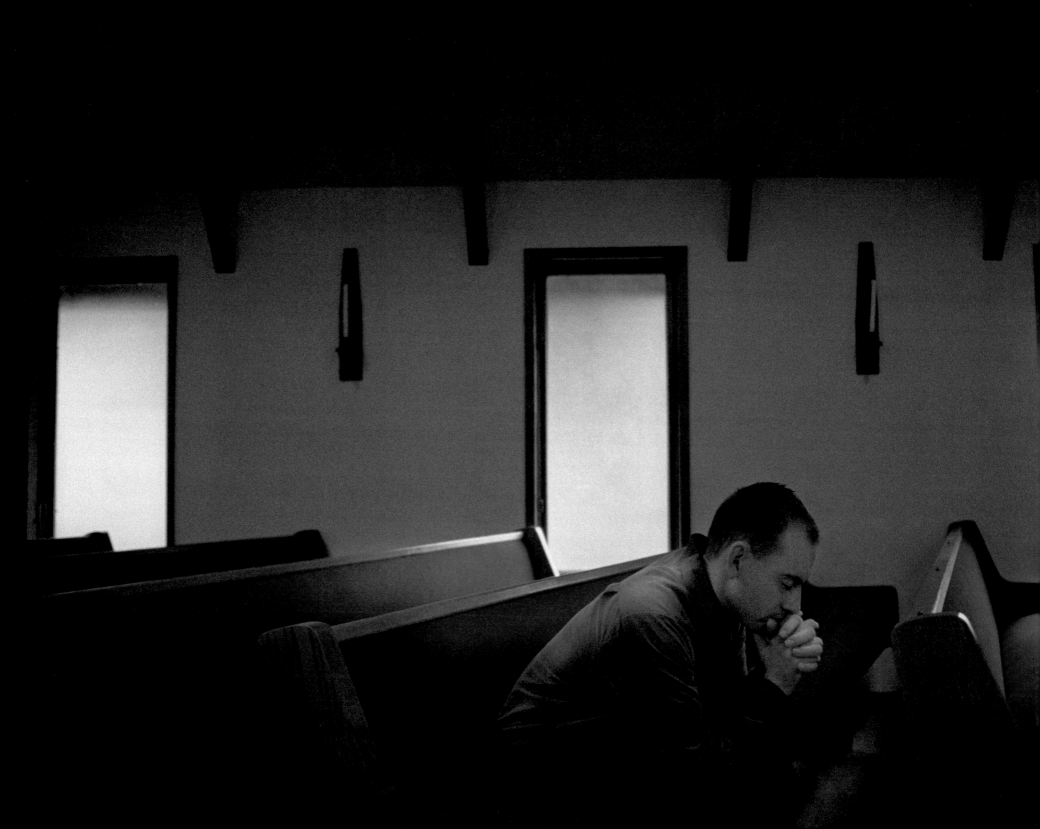

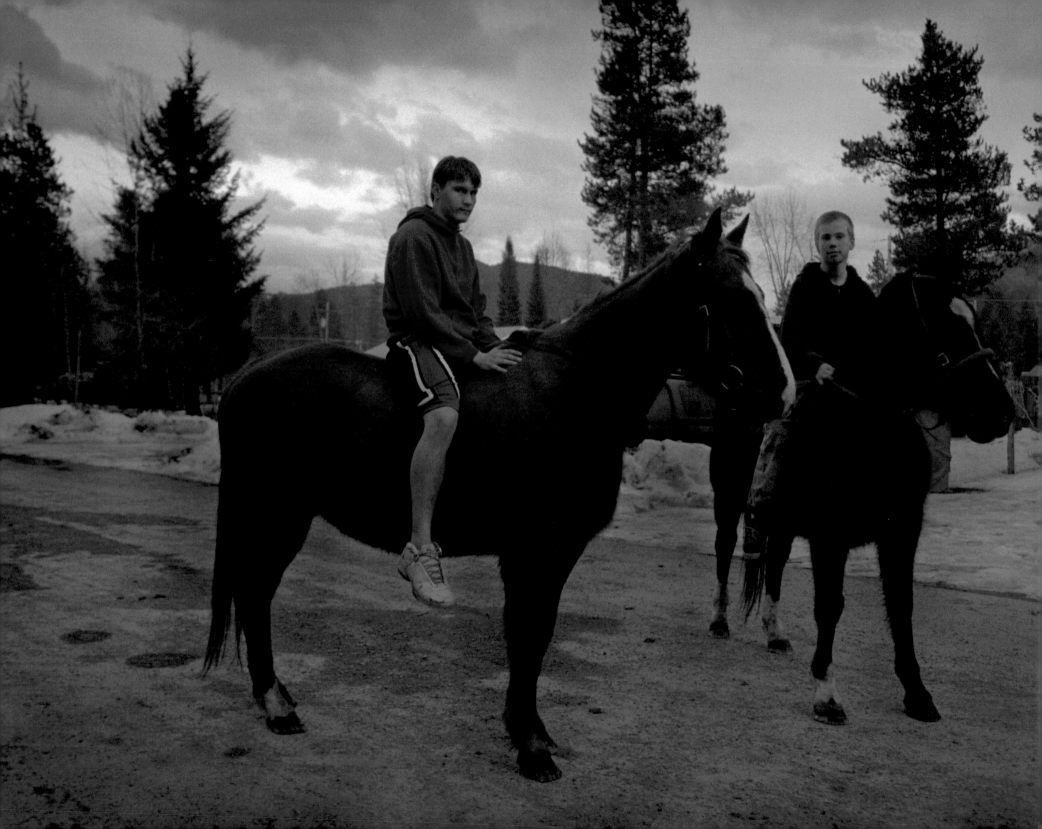

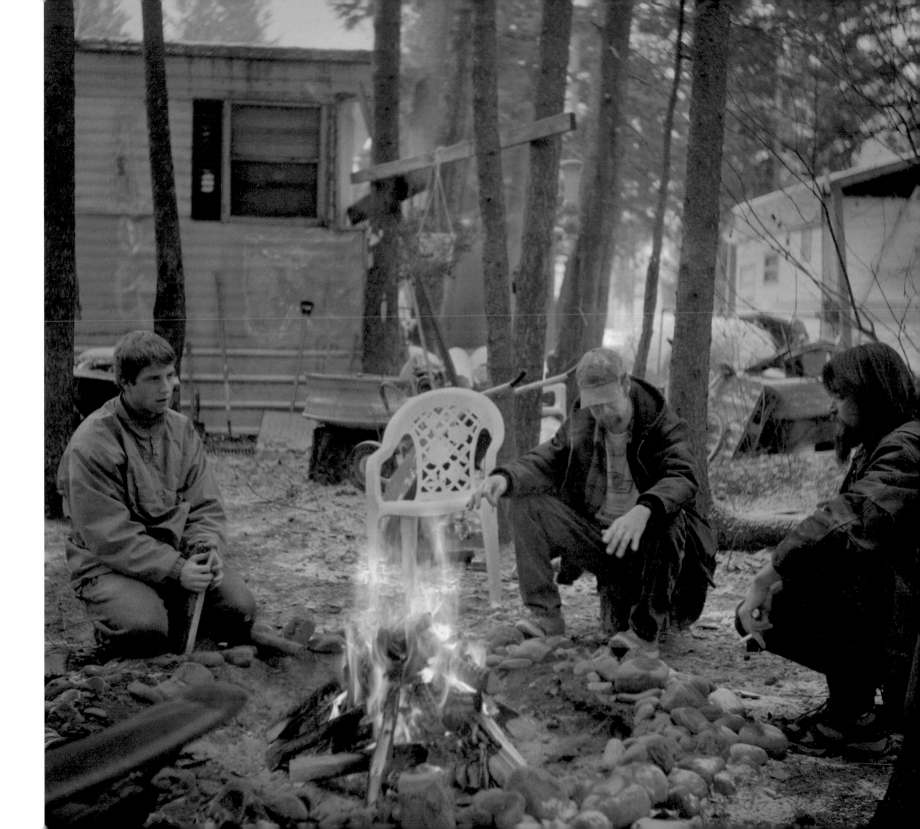

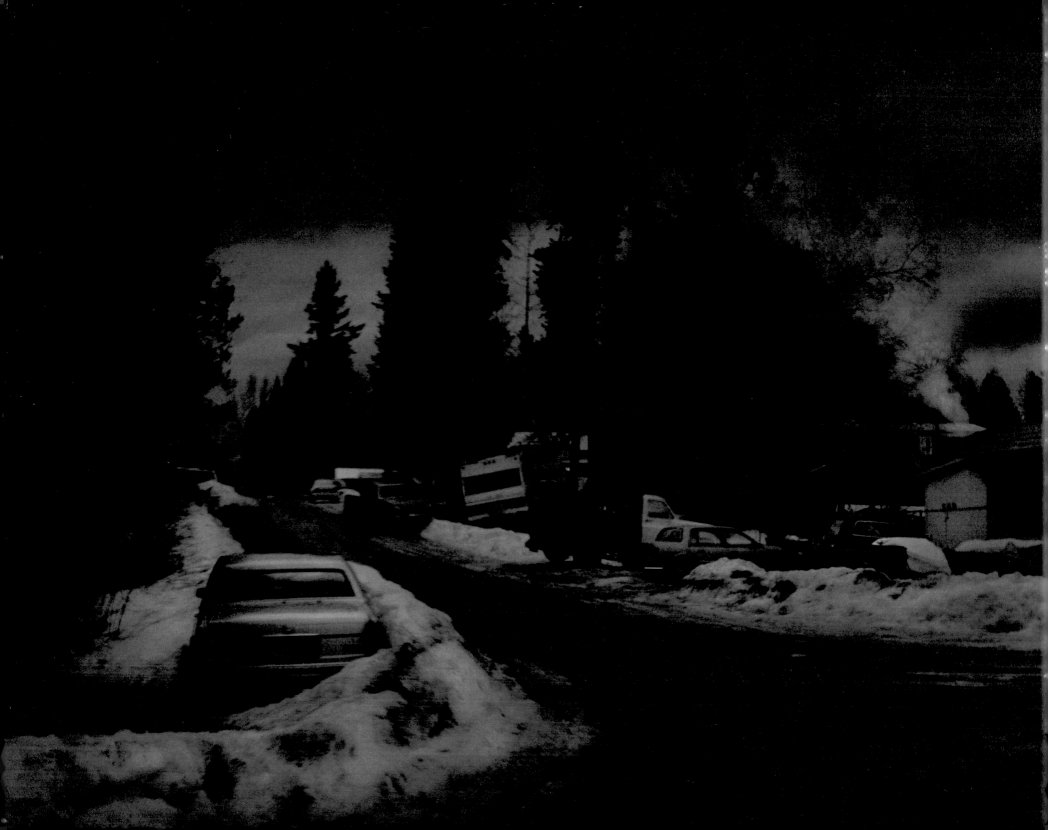

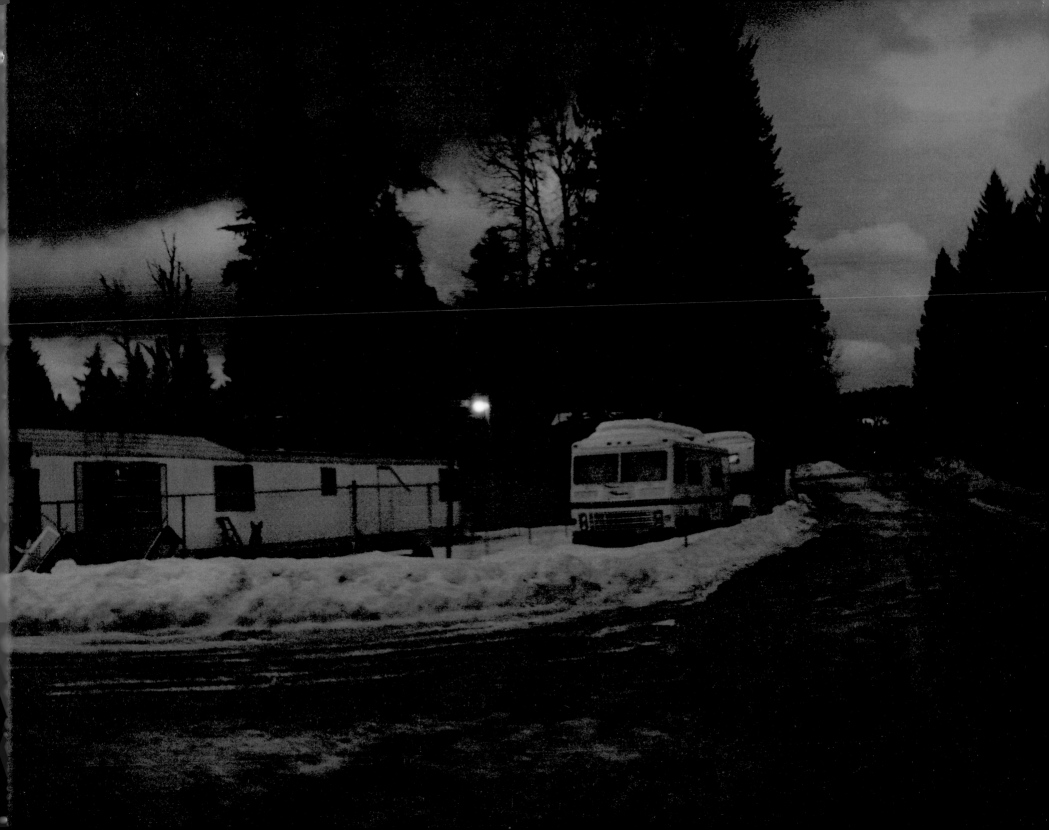

The book is dedicated to Harry Knippers

In love with Montana

*"I'm in love with Montana. For other states
I have admiration, respect, recognition, even
some affection. But with Montana it is love."*

These are the only words John Steinbeck
used to describe Montana in his novel,
Travels with Charley: In Search of America,
published in 1960.

In 2003, a little before the US presiden-
tial elections, (George W. Bush was elected
for the second time and fighting terror-
ism), I decided that I wanted to document
the USA through one town, one small
environment.

This is the story of Hungry Horse, situ-
ated in the Montana Rocky Mountains
just a few miles from Glacier National
Park. Hungry Horse and its neighboring
area mostly depend on the summer tour-
ist season. Winters are quiet and there is
little work in the canyon. Glacier National
Park provides many with work and keeps
big parts of the canyon going. Over the
years many local industries have disap-
peared or been relocated to other places.
The recession of 2007 was hard on this

area, as on so many other small towns
through the US.

I have been documenting this area for
over 10 years. I have seen people come
and go from the canyon. My photographic
documentation is not as much factual as
emotional. The work itself is based on a
state of mind through the people and the
landscapes.

The film we produced through the
year's witch you also find in the book is
based on interviews done with people
who have been part of the project from
almost the first beginning.

I think it took me more than ten years
to understand this place and c beyond the
clichés of the USA.

I have travelled and worked in the
US over more than 15 years on numer-
ous projects but I keep coming back to
John Steinbeck's quote. I'm in love with
Montana.

Stockholm, January, 2015
Pieter ten Hoopen

Cover: Jeremy Adams,
Hungry Horse

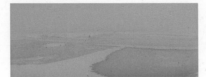

02 Glacier National Park,
Lake McDonald

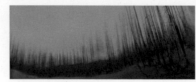

04 Glacier National Park

06 Flathead river

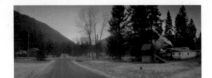

18 Hungry Horse

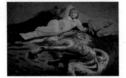

20 Tamy Lee, Hungry Horse

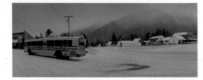

22 Hungry Horse

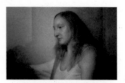

24 Sarah, Hungry Horse

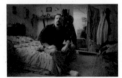

26 Bill, Hungry Horse

28 Jeremy, Hungry Horse

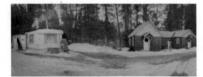

30 Coram

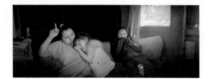

32 Shoan and her family

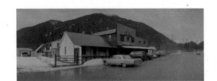

34 Hungry Horse

37 Jeremy, Hungry Horse

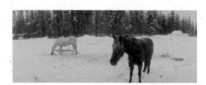

38 Coram

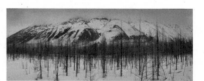

40 Glacier National Park

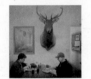

43 Bobs Café,
Hungry Horse

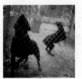

44 Hungry
Horse

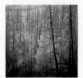

45 The dam
reservoir

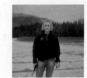

47 Katie Kosnoff,
Hungry Horse

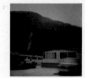

48 Hungry Horse

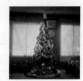

49 Hindberg
recidence, Coram

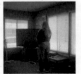

50 Bernice,
Coram

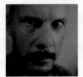

53 Reg, Hungry
Horse

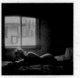

54 Katie, Hungry
Horse

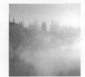

55 Glacier
National Park

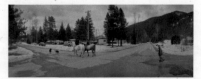

56 Hungry Horse

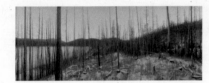

58 Hungry Horse dam reservoir

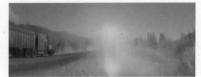

60 Highway 2, Glacier National Park

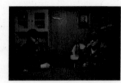

62 RJ and his brother Jim

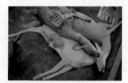

64 Highway 2,
Glacier National Park

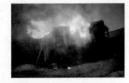

66 Hungry Horse

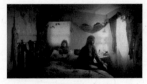

68 Melissa, Hungry Horse

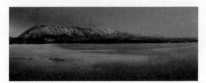

70 Lake McDonald, Glacier National Park

73 Glacier National Park

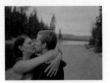
74 Jessica and Aaron

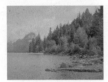
76 Lake McDonald, Glacier National Park

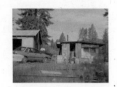
77 Martin City, Charles former house

79 Emily, Hungry Horse reservoir

80 Charlie and Cindy, Martin City

83 Flathead river

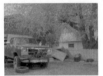
84 Aarons place

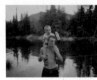
85 James and Blake, Glacier National Park

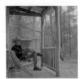
86 Brad Lee Bruursema, Hungry Horse

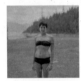
89 Emily, Hungry Horse reservoir

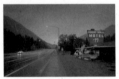
90 Hungry Horse

92 Hungry Horse

93 Hungry Horse

95 Deerlick Saloon, Martin City

96 Hungry Horse

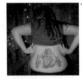
97 Packers Roost, Coram

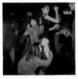
99 Packers Roost Coram

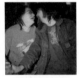
100 Charlie and Cindy, Deerlick Saloon

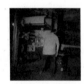
101 Cindy, Deerlick Saloon

102 Denise, Damtown tavern, Hungry Horse

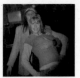

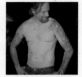
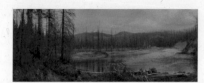

105 Stevo and
Sleevo, Packers
Roost, Coram

106 Terry and
dance partner,
Packers Roost,
Coram

107 Hungry Horse

109 Stevo, Packers
Roost, Coram

110 Flathead River, Glacier National Park

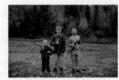
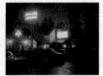
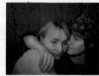
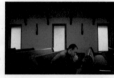
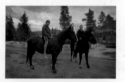

112 Young boys
hunting birds,
Hungry Horse dam

114 Stonefly
lounge, Coram

115 Tamy Lee and
Jill, Hungry Horse

116 Cody, Hungry Horse
church

118 The Nelson brothers,
Hungry Horse

121 Aaron, Sam
and Charlie,
Hungry Horse

122 Hungry Horse

Pieter ten Hoopen

Photographer and filmmaker Pieter ten Hoopen was born in 1974 in the small town of Tubbergen in eastern Netherlands. After studying Forestry he moved to Sweden in 1998 to work in the woods. He did this for a few years until he changed direction and studied Photojournalism at Nordens Fotoskola, and has, since 2002, been working as a freelance photographer based in Stockholm. He has attracted wide awareness through his many reports from Pakistan, Russia, Iraq, Afghanistan and other countries. He has been named Photographer of the Year in Sweden three times and has numerous international awards, among others three prizes from the prestigious World Press Photo Contest. Pieter is a member of the VU' Agency since 2008.

Luke Mogelson

Luke Mogelson is an American writer, born in St. Louis, Missouri 1982, and based in Mexico. Between 2011 and 2014, he was a contributing writer in Kabul, Afghanistan, for The New York Times Magazine. 2014–2015 he was reporting from Syria and West Africa for The New Yorker Magazine. Mogelson is the recipient of a National Magazine Award and a Livingston Award.

Thanks to

Katie Kosnoff, Brad Lee Bruursema, Charlie Krasselt, Christian Rhen, Aaron Harris, Doug Woehler, Tamarack Lodge, Anna Louise Stene, Luke Mogelson, Agency Vu, Media Storm, Tim McLaughlin, Max Ström, Jeppe Wikström and Marika Stolpe, Stefan Bladh, Anna Clarén, Erik Lindeman, Johan, Ineke, Gineke, Liedeke, Jan and Marjolein ten Hoopen, Bertil Lindgren, Harry Knippers, Galleri Kontrast, Nikon, Knut Kainz Rognerud, Peter Letmark, Magnus Nygren, Viveka Blom Nygren, Maria Agrell, John Steinbeck, Thomas ter Beke, Ruben Harink, Martin von Krogh, Marco van Basten, Chris Maluszynski, Asel Al-Baldawi, ZooPeople, Mattias Johansson Skoglund, and all of you who have supported the Horse through the years.

Special thanks to

Christian Rhen, Terese Cristiansson, Brian Storm and Anders Birgersson for being part of the book and film from the first beginning.

© Bokförlaget Max Ström, 2015
© Photography: Pieter ten Hoopen
Text: Luke Mogelson and Pieter ten Hoopen
Design: Anders Birgersson
Repro and printing:
Göteborgstryckeriet, Sweden, 2015
ISBN 978-91-7126-313-1
www.maxstrom.se